PEOPLE OF THE PRIDE PARADE

PEOPLE OF THE PRIDE PARADE

PHOTOGRAPHS BY ALYSSA BLUMSTEIN

APOLLO
PUBLISHERS

Apollo Publishers books may be purchased for educational, business,
or sales promotional use. Special editions may be made available upon request.
For details, contact Apollo Publishers at info@apollopublishers.com.

Visit our website at www.apollopublishers.com.

Published in compliance with California's Proposition 65.

Library of Congress Cataloging-in-Publication Data is available on file.

Photographs by Alyssa Blumstein
Design by Rain Saukas

Print ISBN: 978-1-948062-58-9
Ebook ISBN: 978-1-948062-59-6

Printed in the United States of America.

PREFACE

I n the early morning hours of June 28, 1969, police raided the Stonewall Inn, a bar in New York City's Greenwich Village that was a frequent gathering place for New York's gay, lesbian, and transgender community. Police had long been in the practice of raiding bars and nightclubs thought to cater to the gay scene, but this time the community fought back and rioted into the dawn, marking the beginning of the modern fight for LGBTQ+ rights.

In the years that have followed, members of the LGBTQ+ community and its allies have taken to the streets of New York City: agitating for change and equality, celebrating sexual freedom, and honoring the brave advocates who came before them. New York City Pride, with its unabashed liberty and open spirit, has provided a time and space for organization, protest, and acceptance, even during bleak, dangerous times—after the assassination of San Francisco Supervisor Harvey Milk and the murder of Matthew Shepard, during the AIDS crisis, and throughout the suppressive days of Don't Ask, Don't Tell.

Today, New York City Pride is a colorful weekend of boisterous parties, invigorating concerts, and life-affirming parades, culminating with the Dyke March and the Pride March, which traverses Manhattan's Fifth Avenue and winds downtown through the technicolor Village streets and toward the Stonewall Inn, attracting tens of thousands of participants—on floats, on foot, in marching bands and dance troupes—and millions of spectators along the way.

To capture the faces of Pride, photographer Alyssa Blumstein took to the streets, camera in hand, during 2019's WorldPride weekend—a landmark celebration of LGBTQ+ rights held on the fiftieth anniversary of the Stonewall Riots. The event was the largest Pride ever, with five million attendees from around the world. What resulted is *People of the Pride Parade*, which brims with colorful portraits of the celebrants—people of all ages, nationalities, races, religions, and economic backgrounds, first-timers and veteran attendees, people who identify as cisgender, LGBTQ+, or somewhere in between. There are couples and friends, solo attendees, and much more; people like Spike and Samantha, William and Brie, Jacob, Bobby, Leanne, and Taylor. Everyone has a different story to tell and a reason for attending. Their colorful clothing, their open-minded attitude, their joy and enthusiasm are what make Pride effervescent, and this one-of-a-kind volume is a visual celebration of them—the people who define and comprise Pride today.

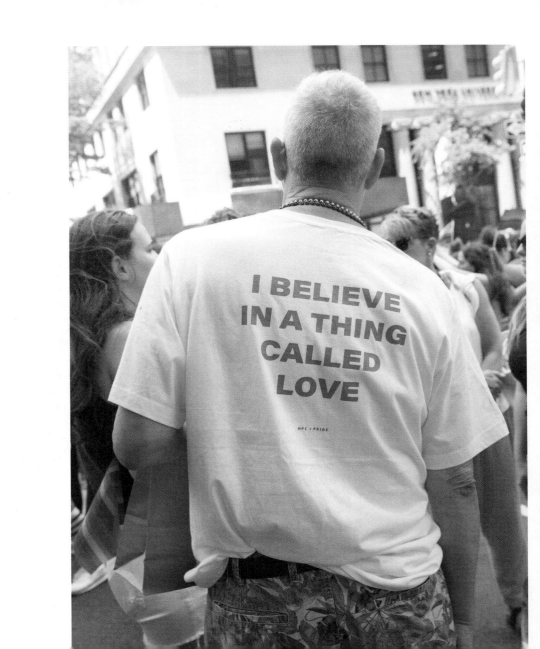

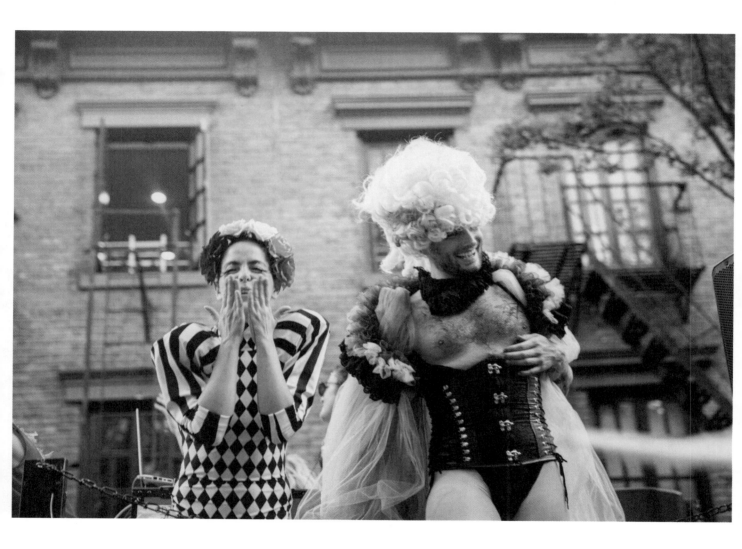

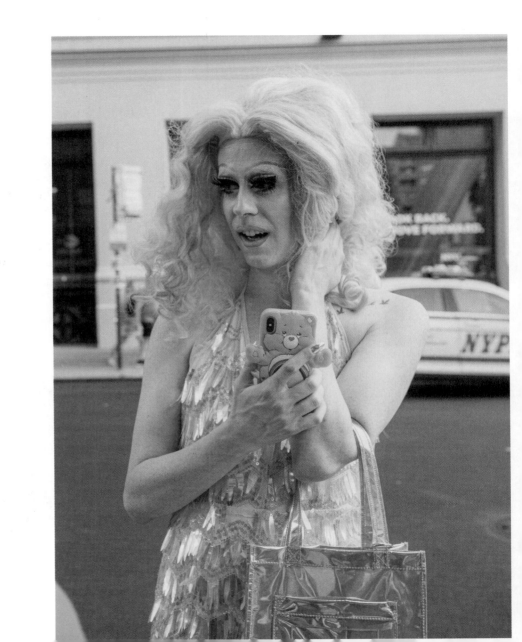

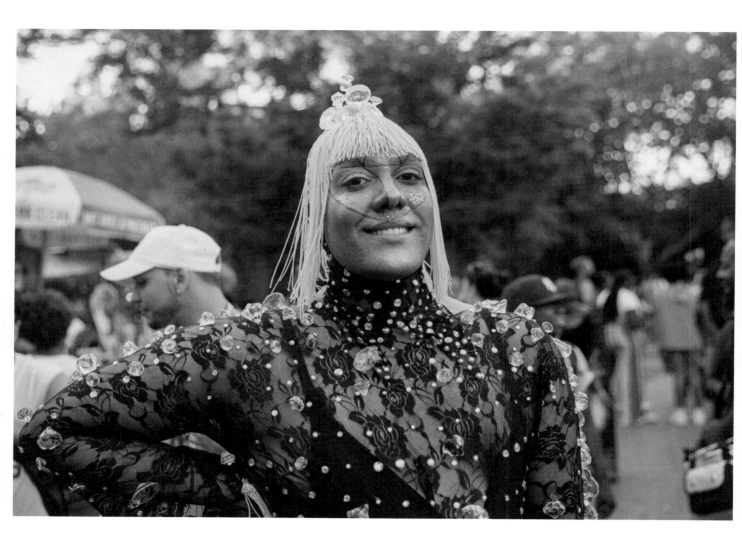

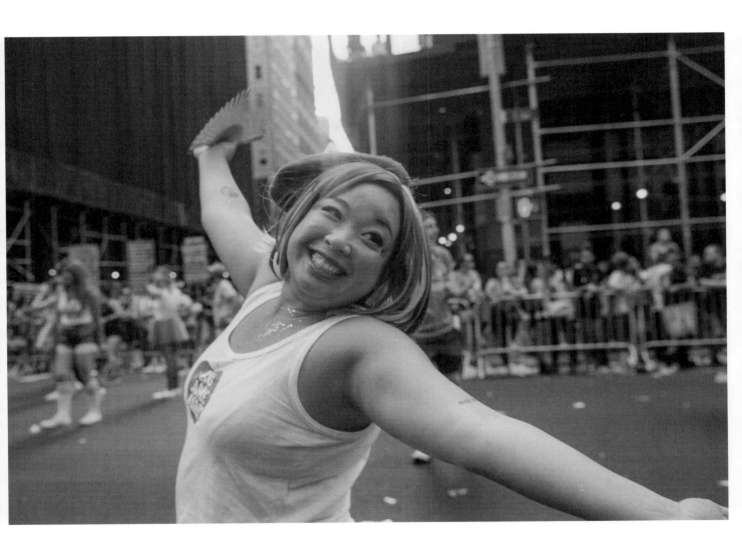

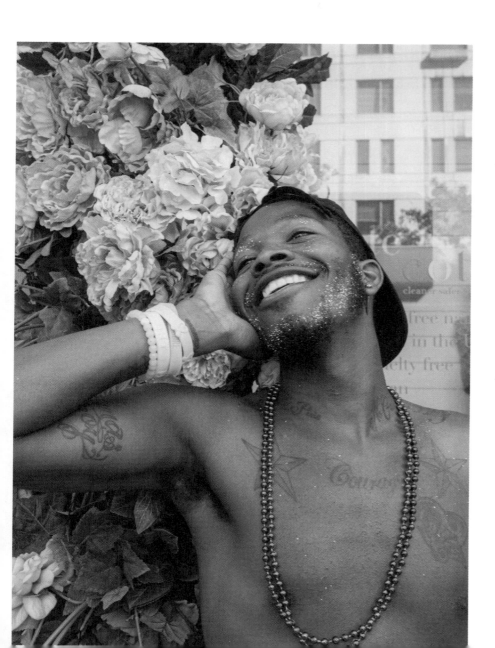

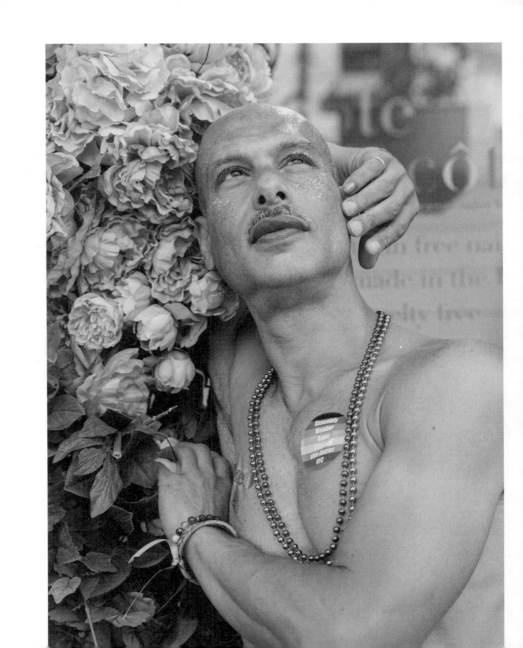

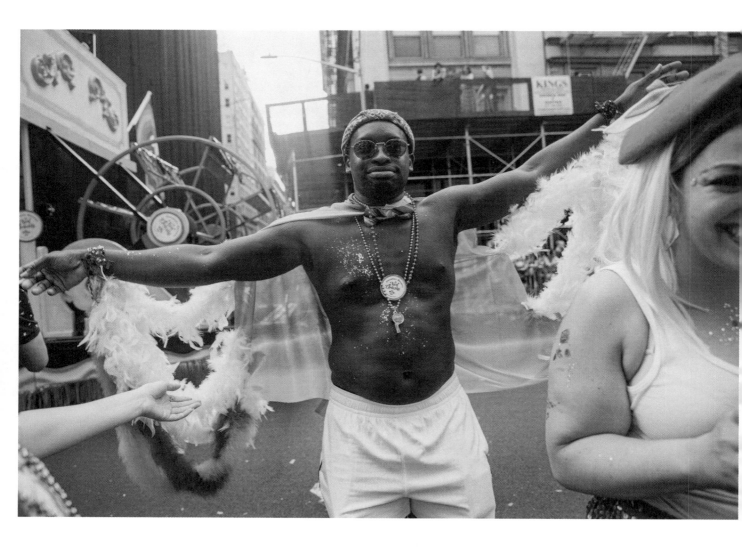

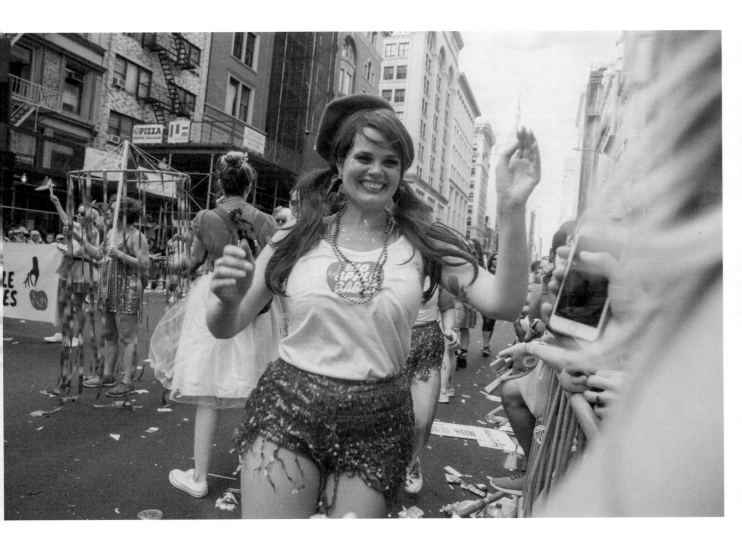

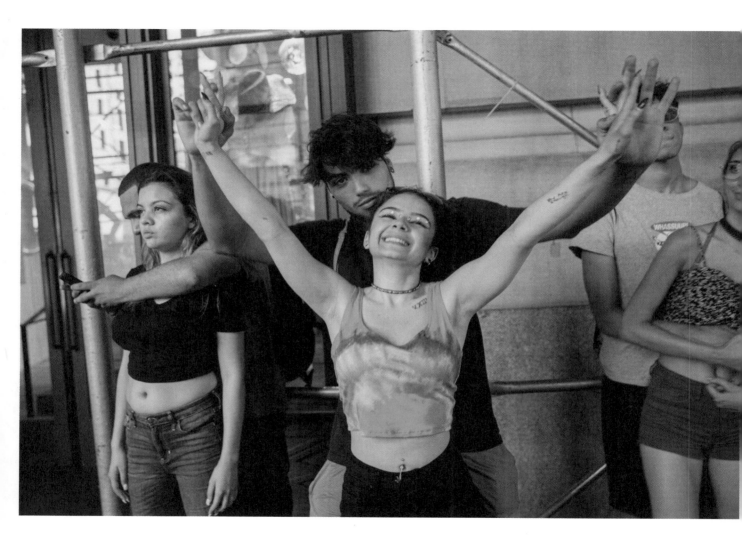

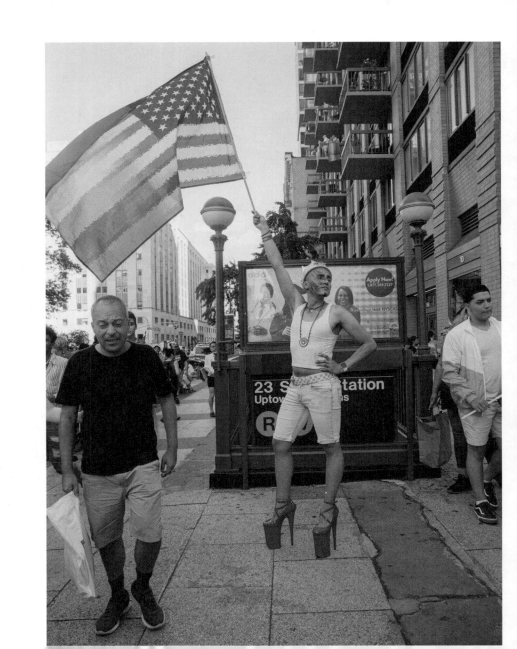

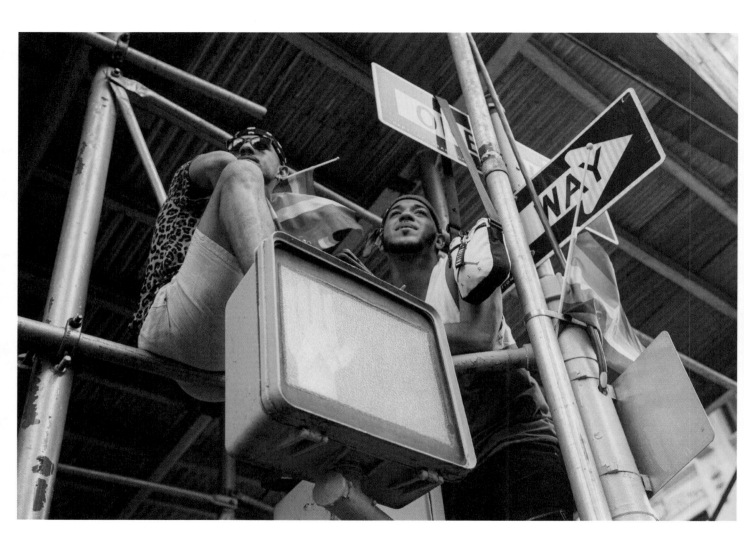

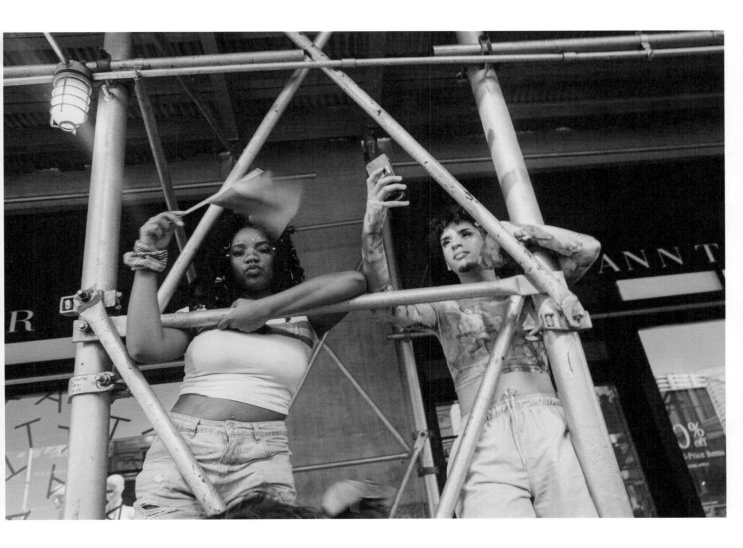

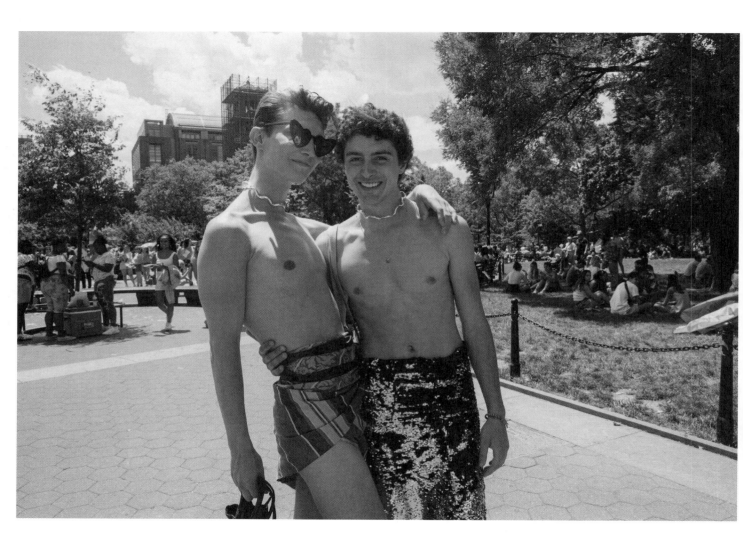

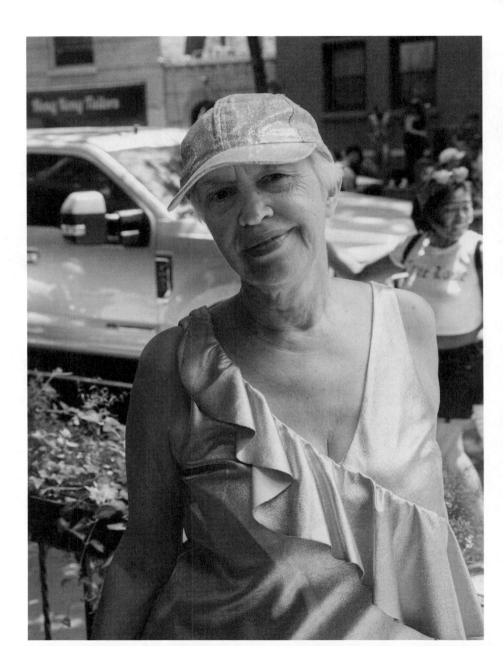

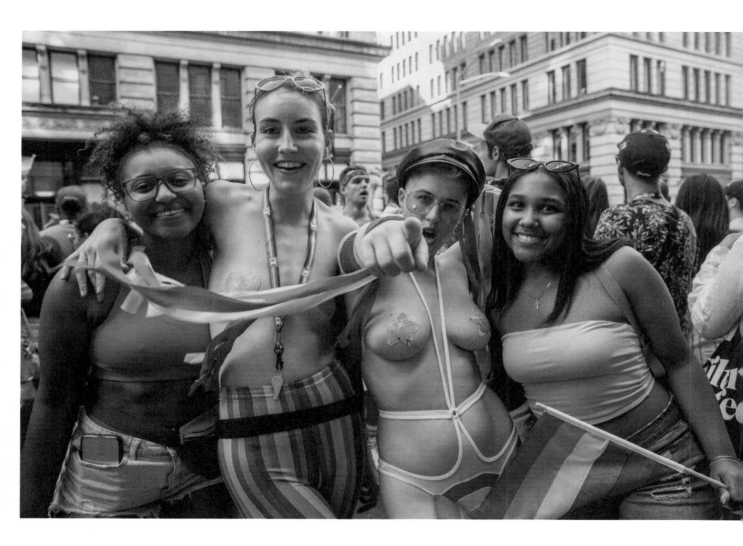

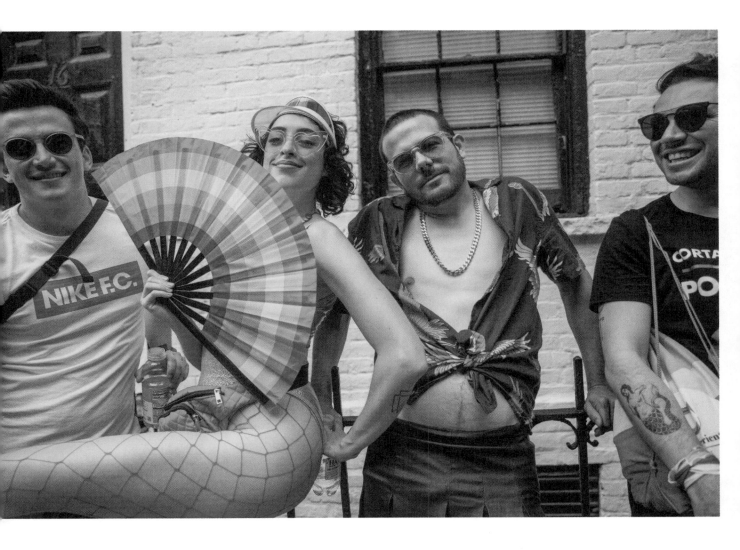

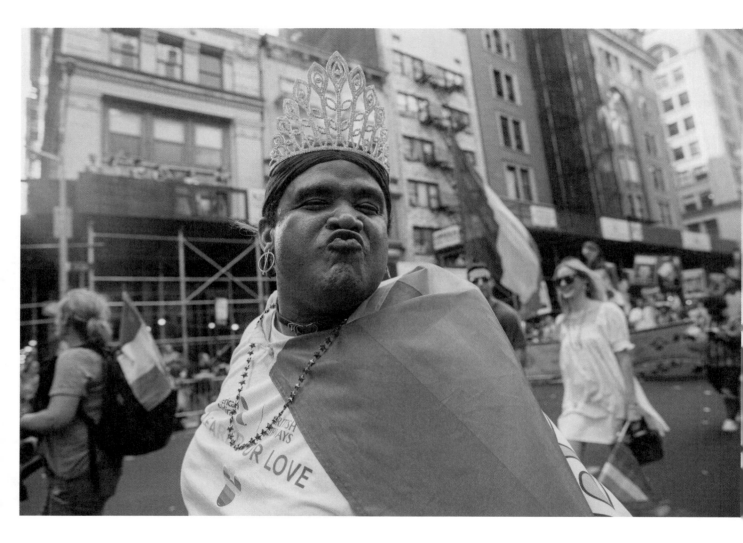

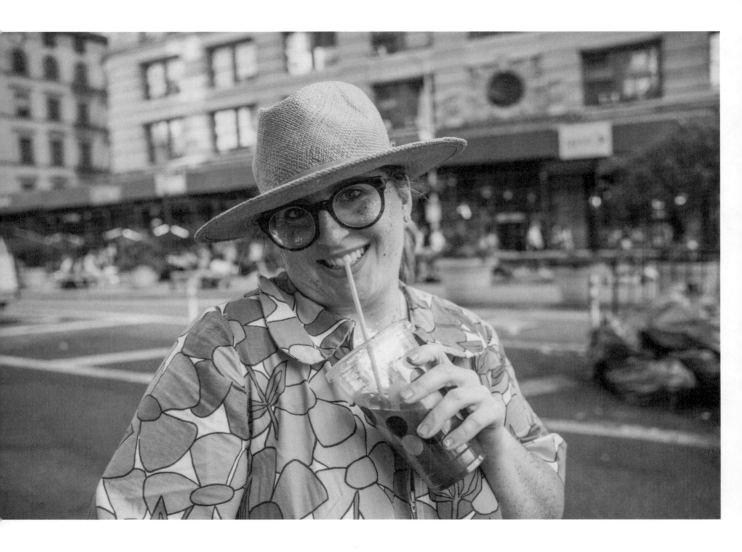

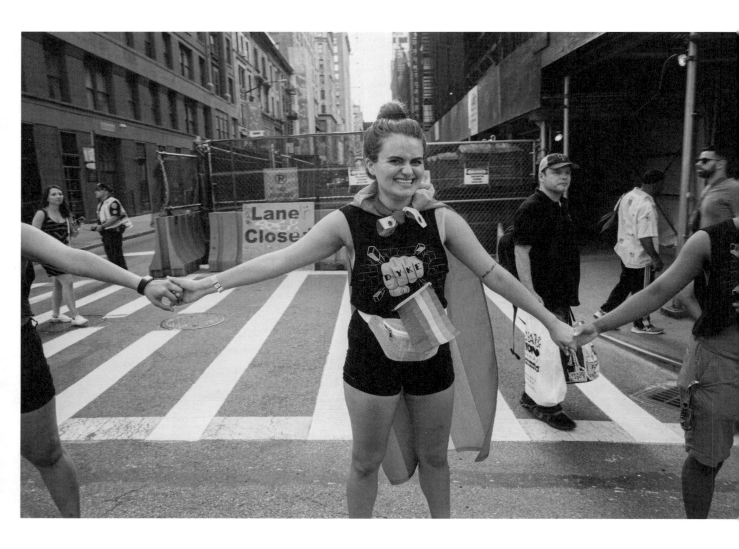

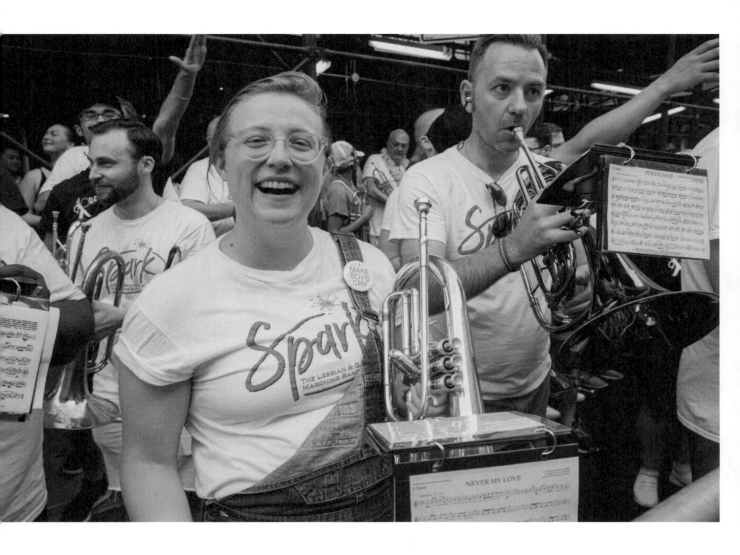

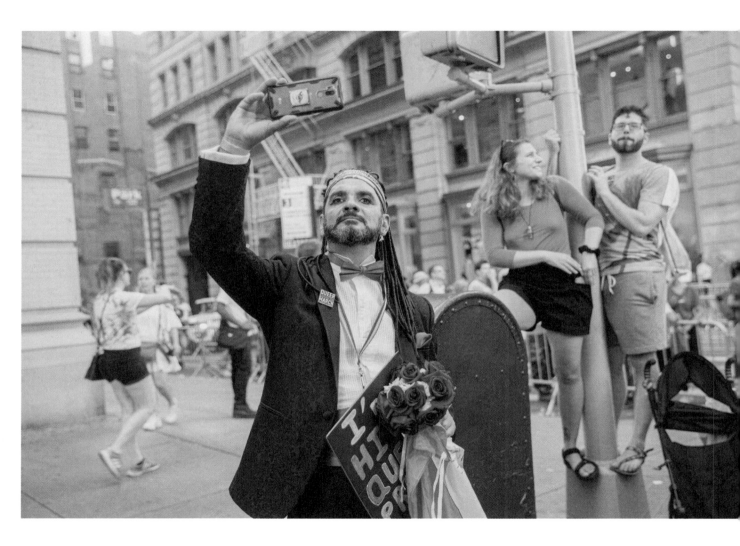

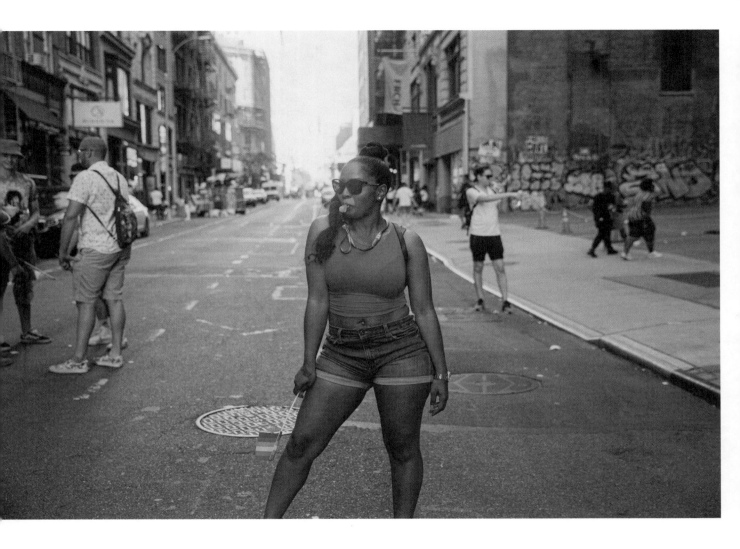

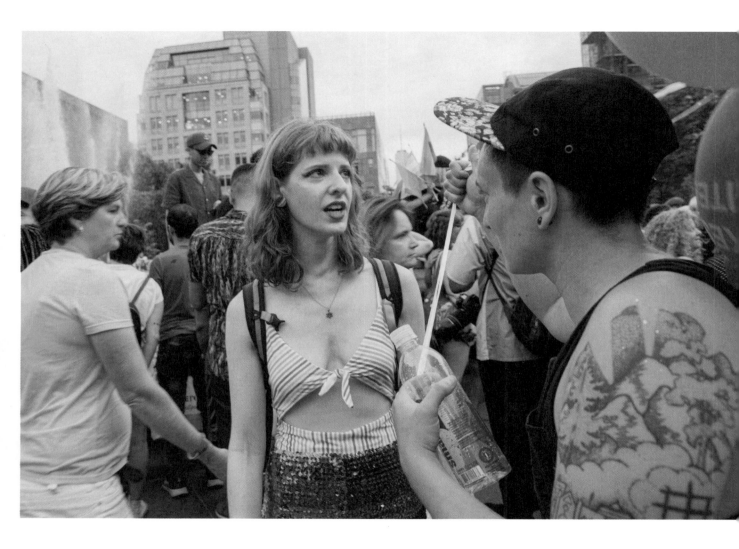

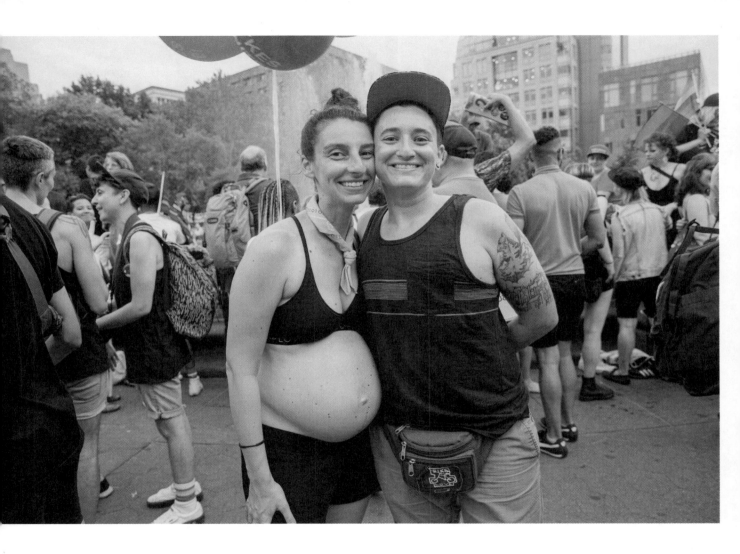

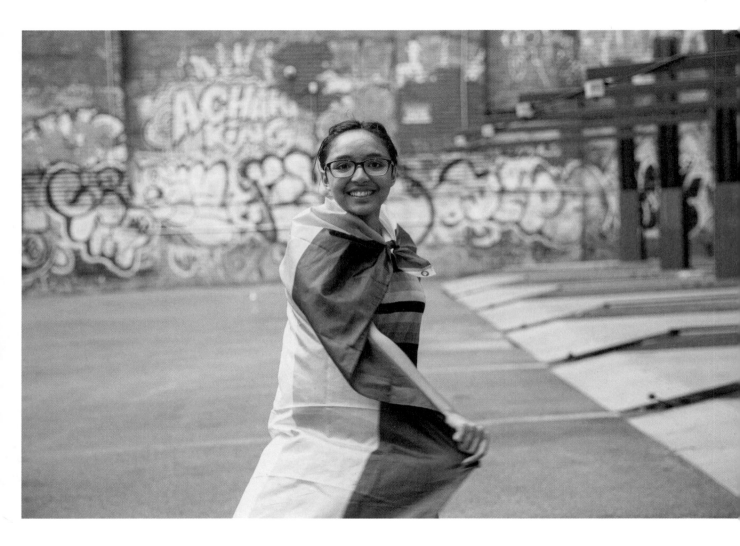

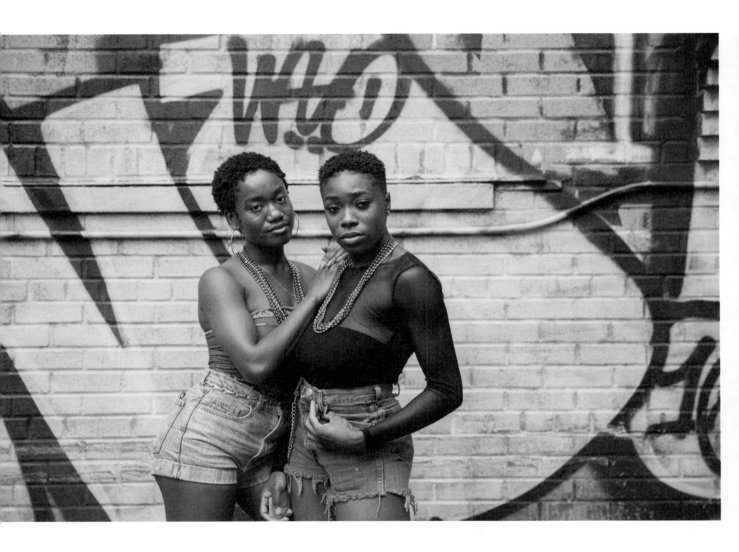

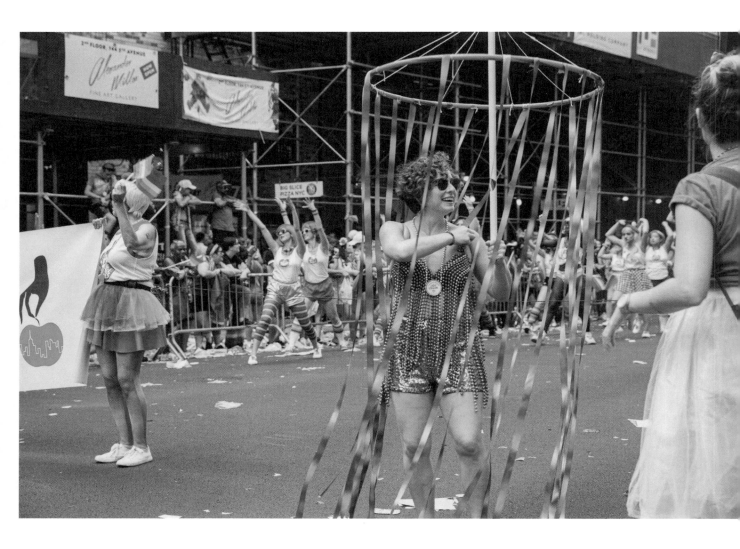

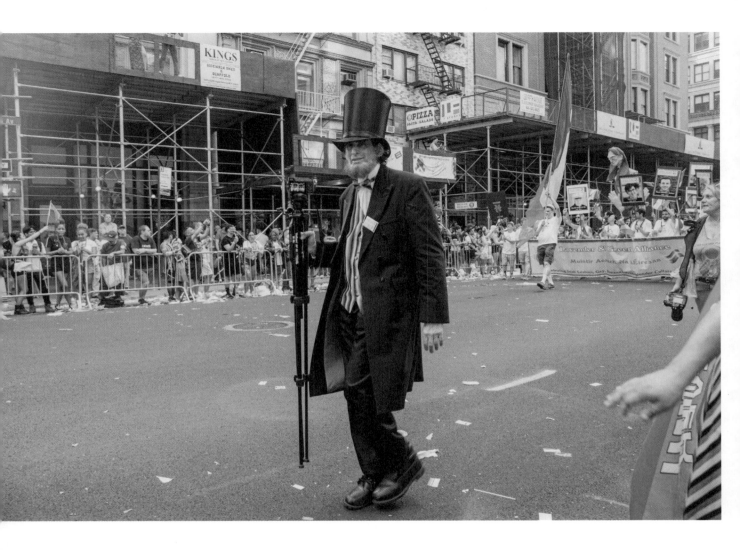

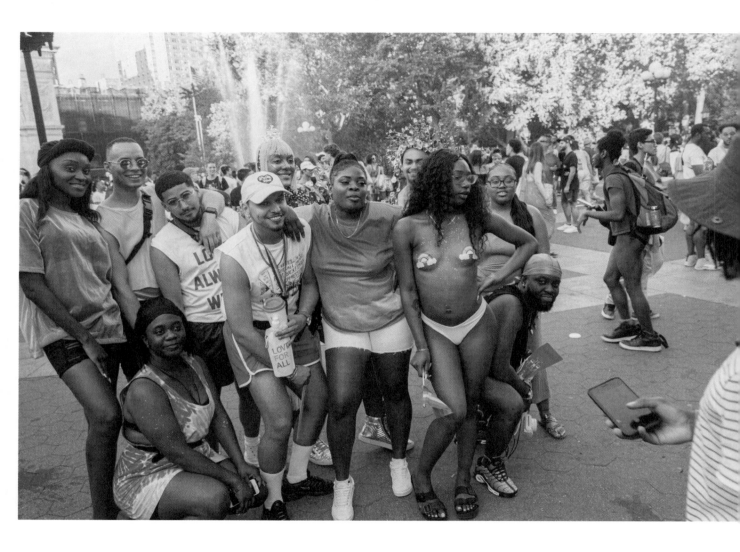

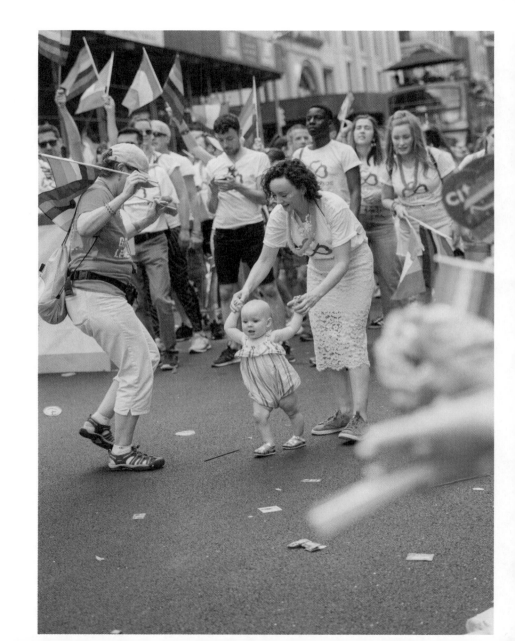

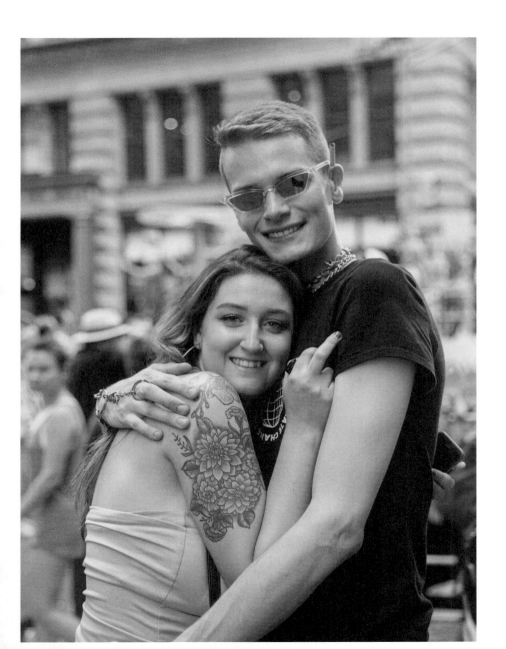

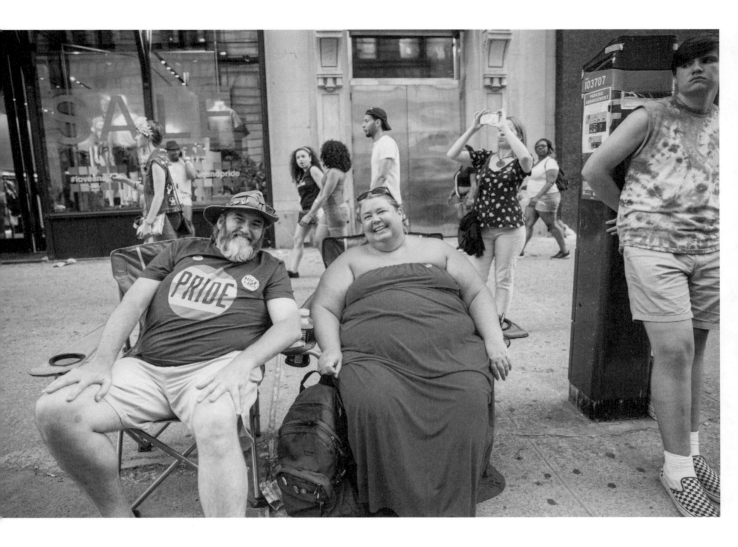

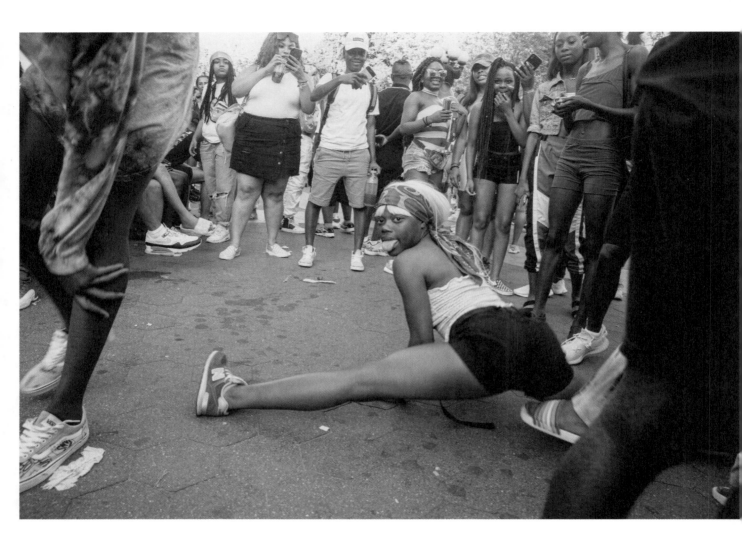

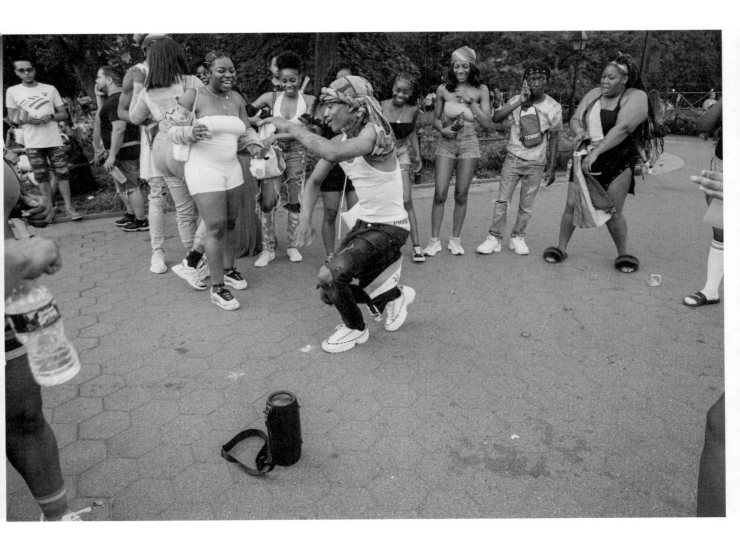

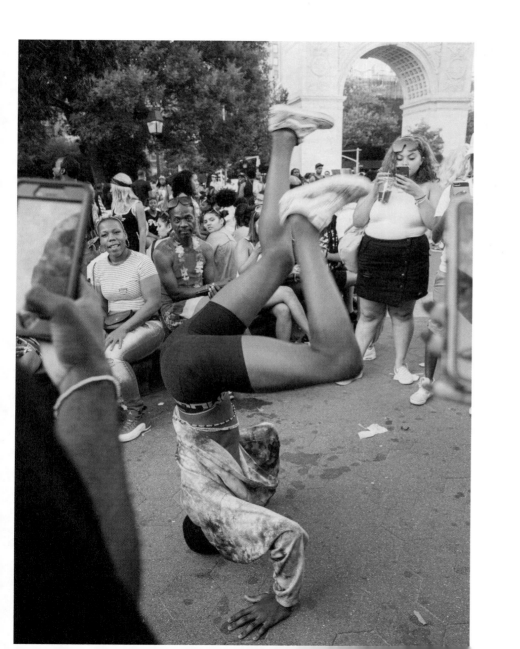

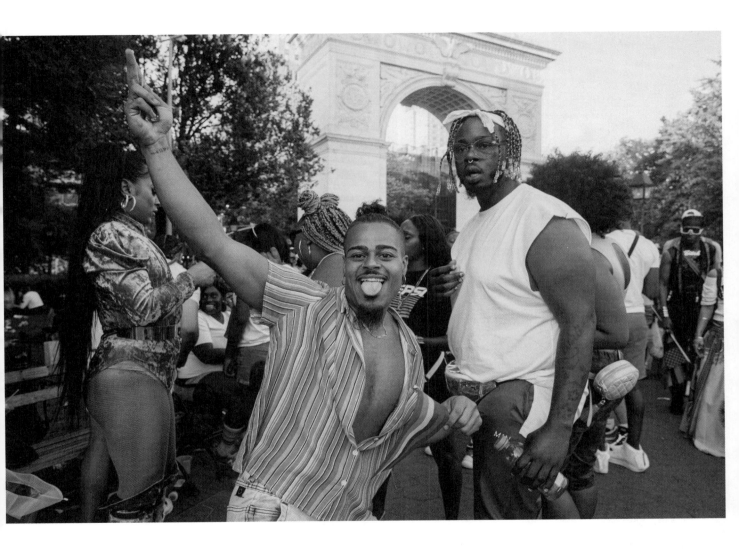

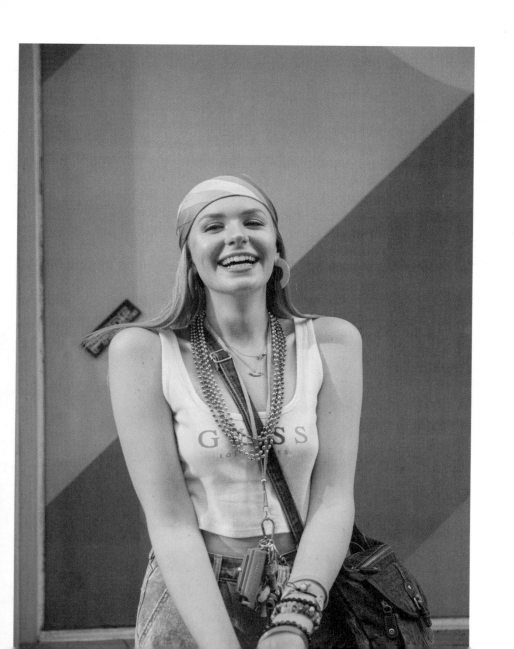

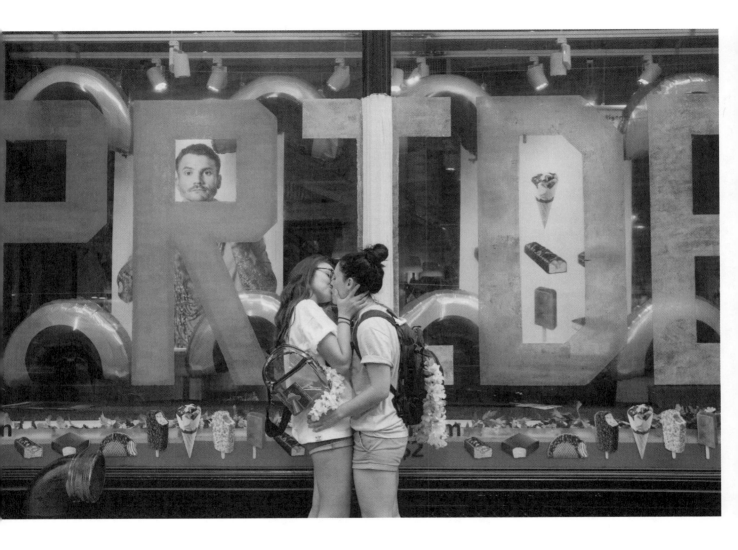

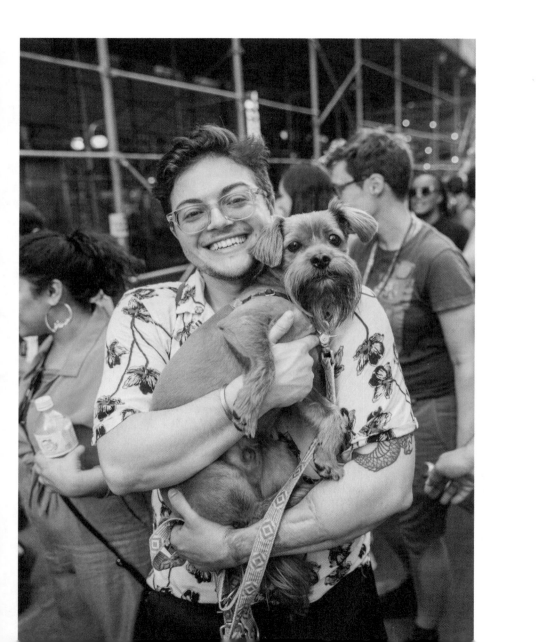

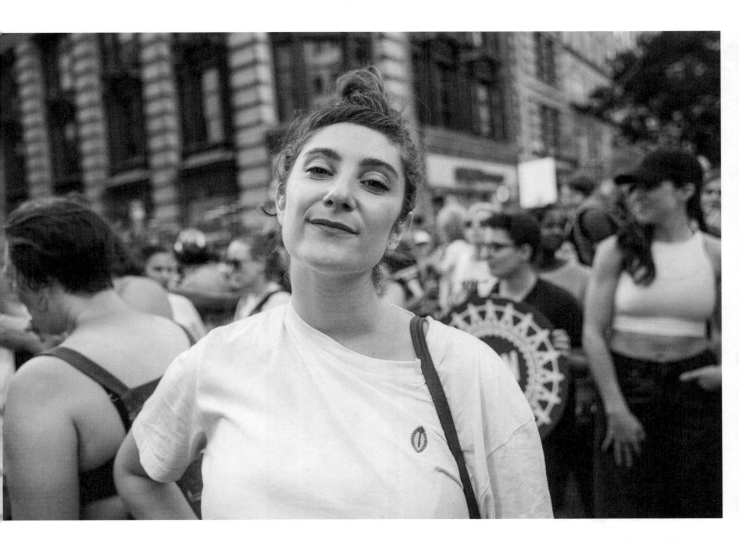

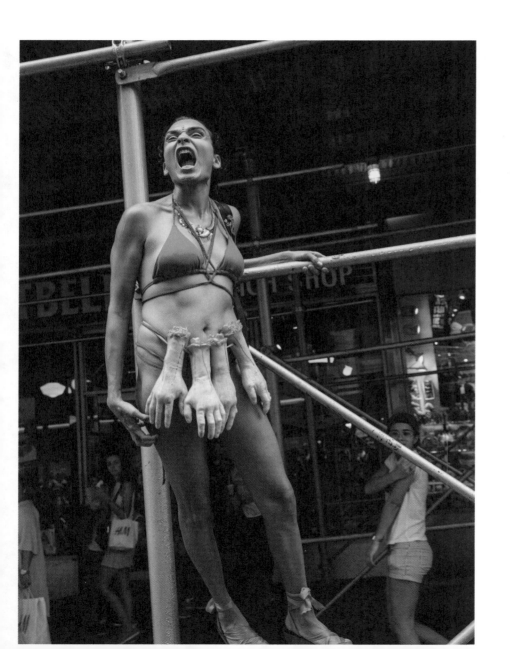

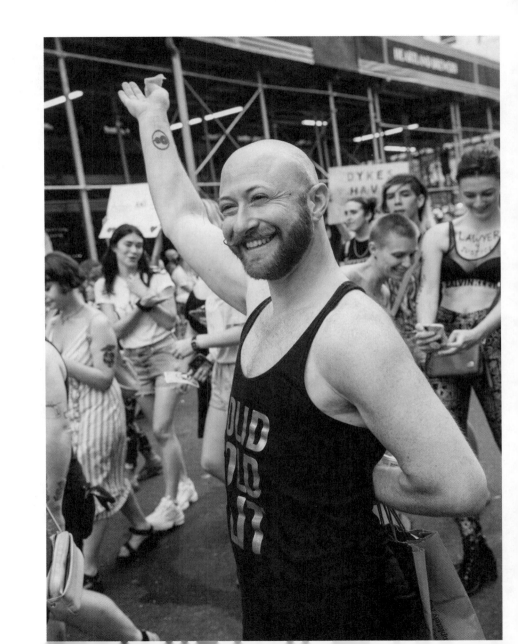

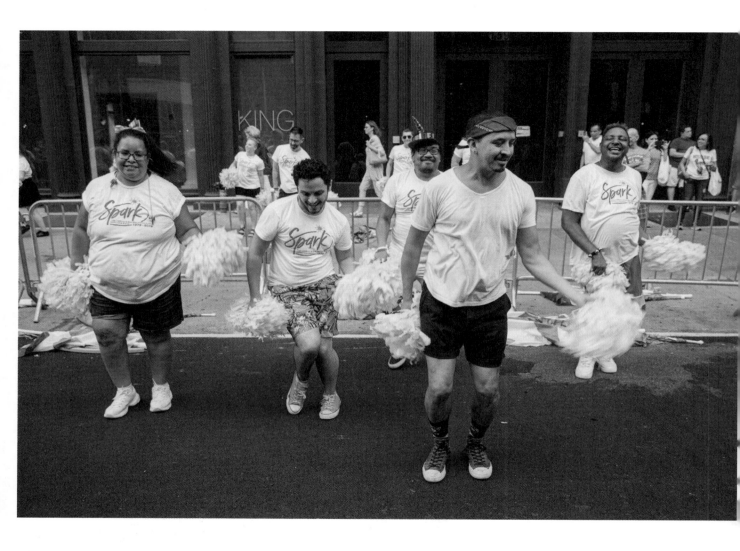

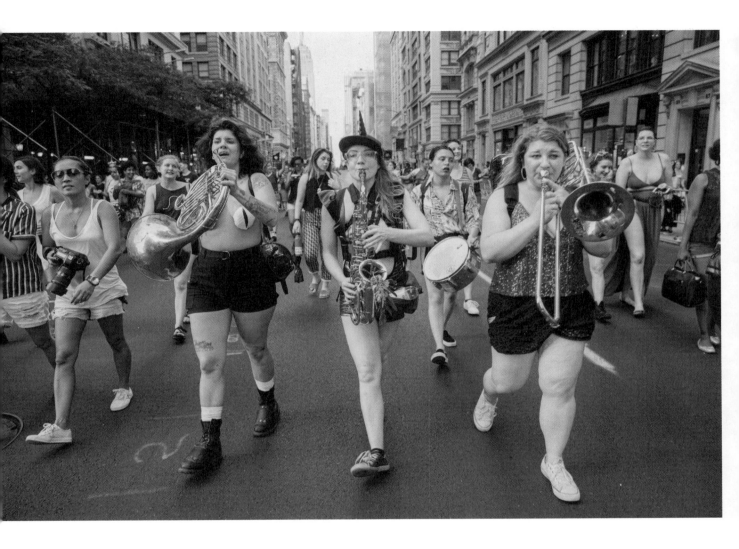

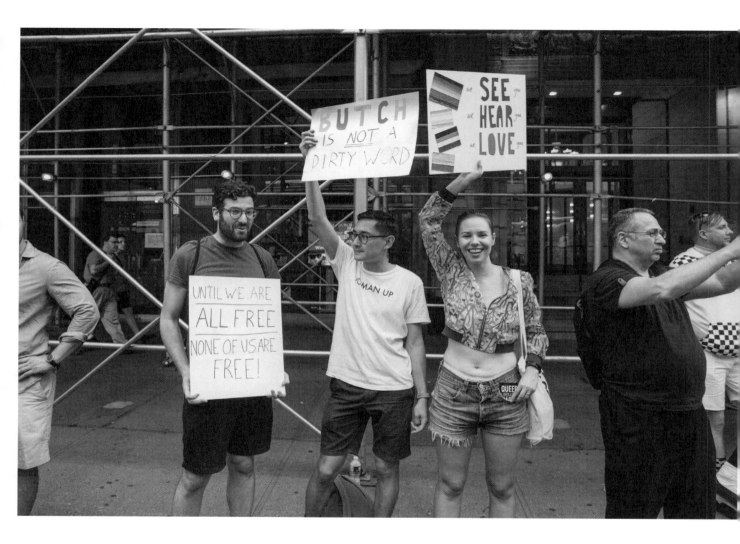

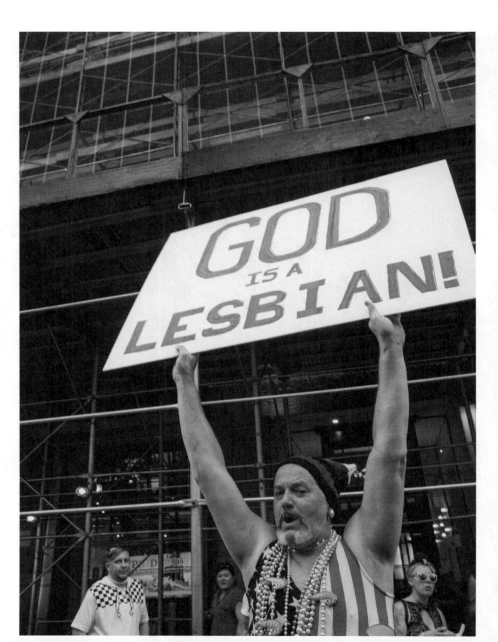

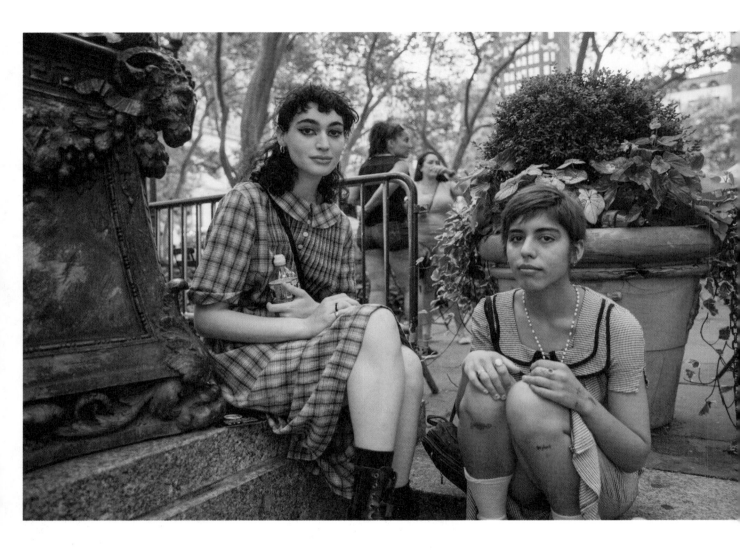

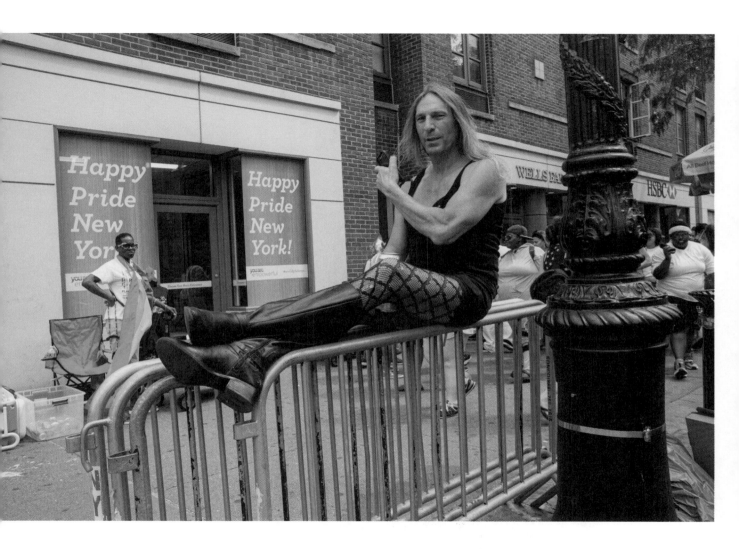

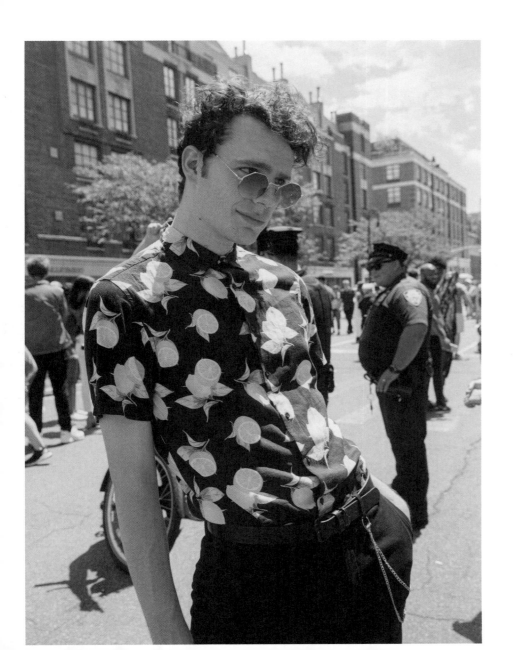

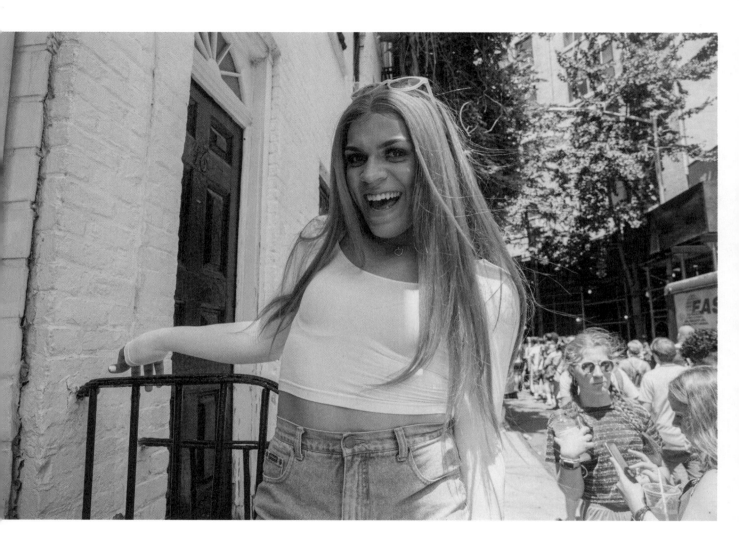

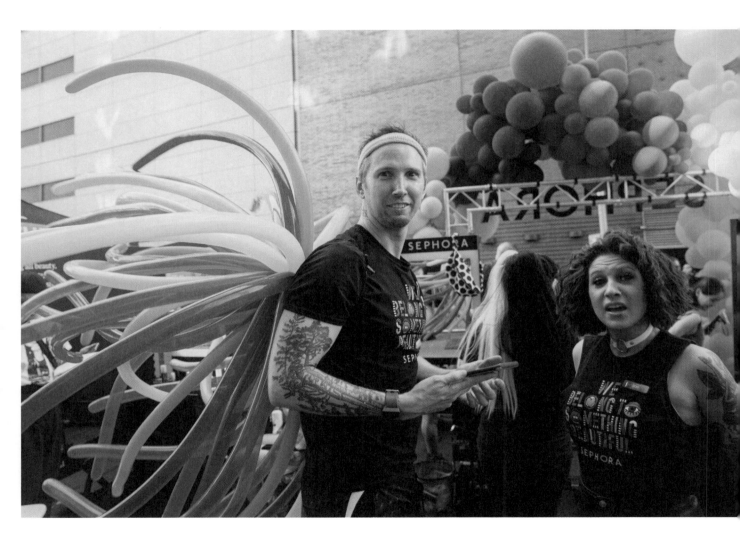

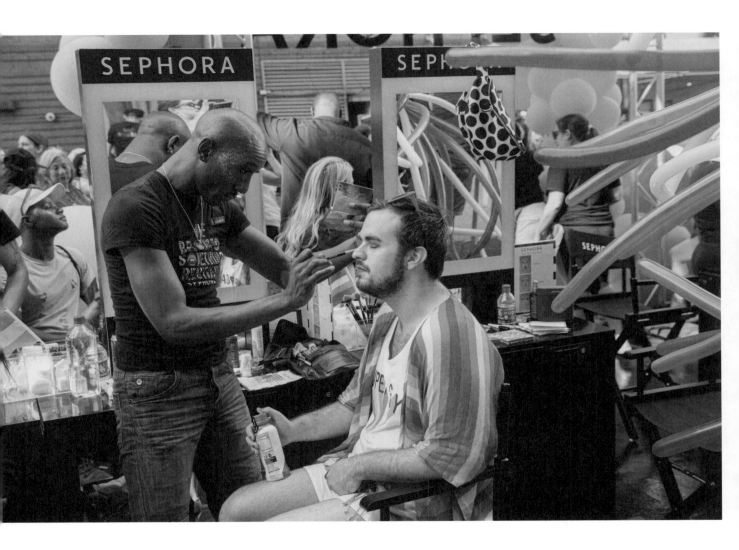

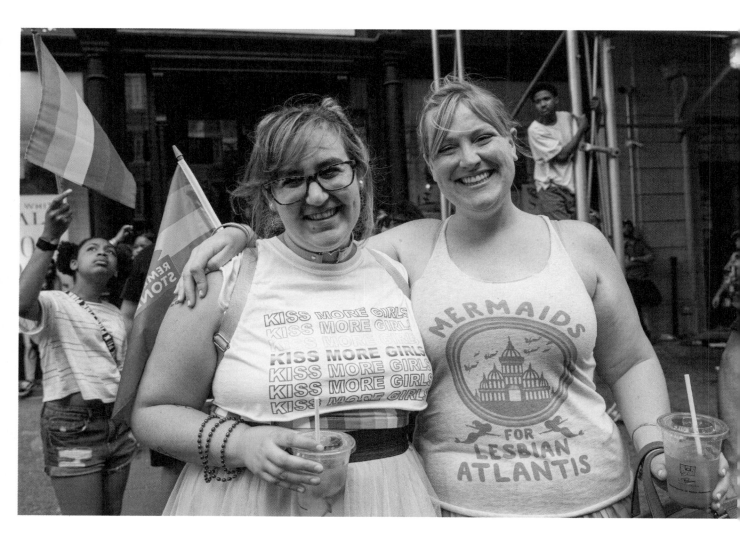

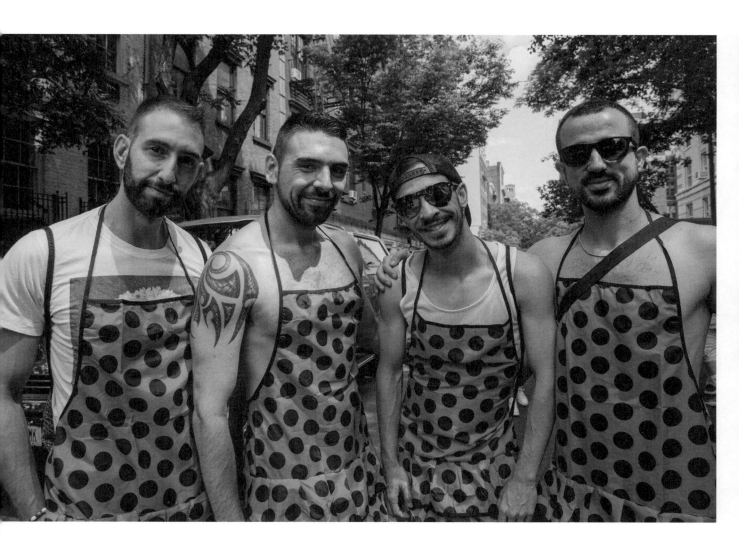

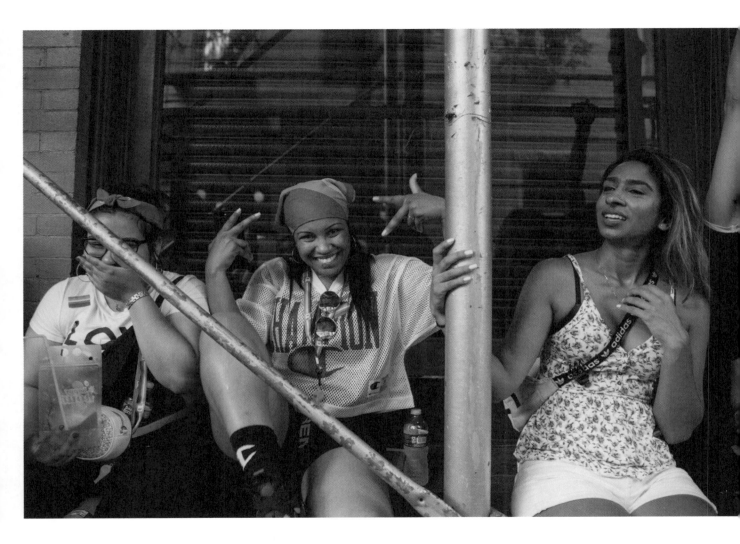

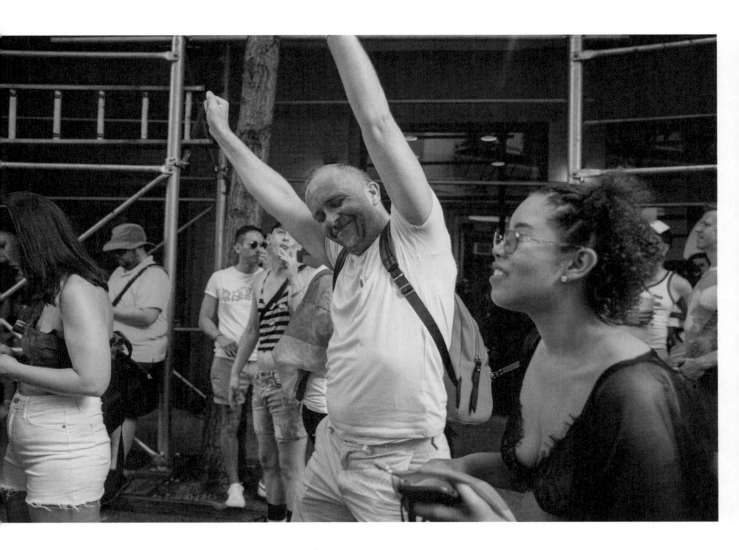

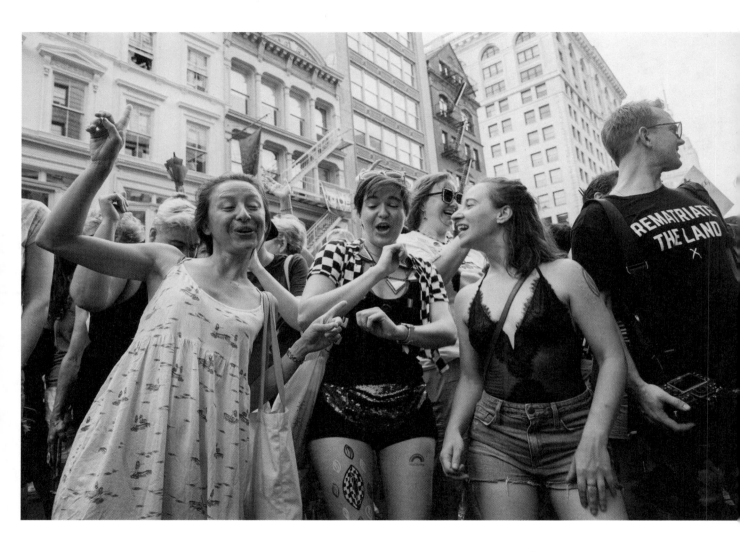

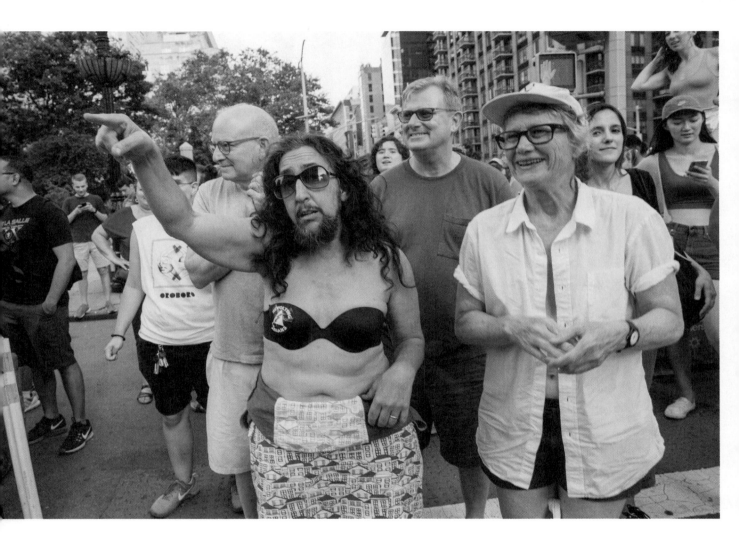

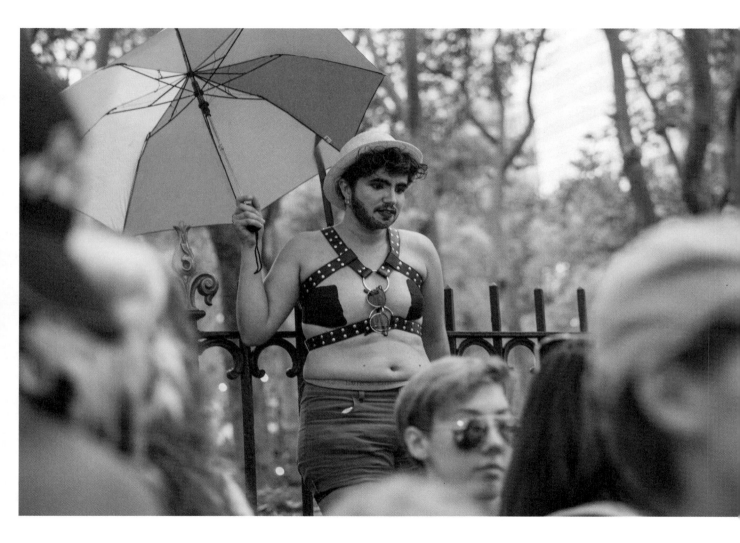

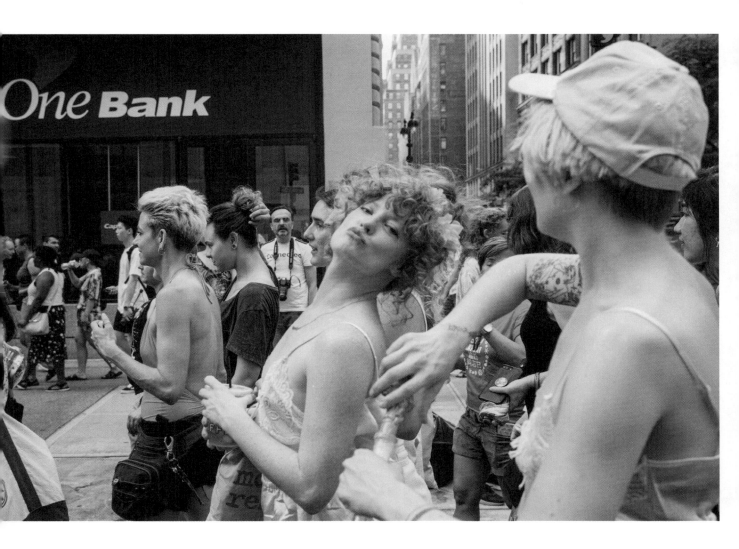

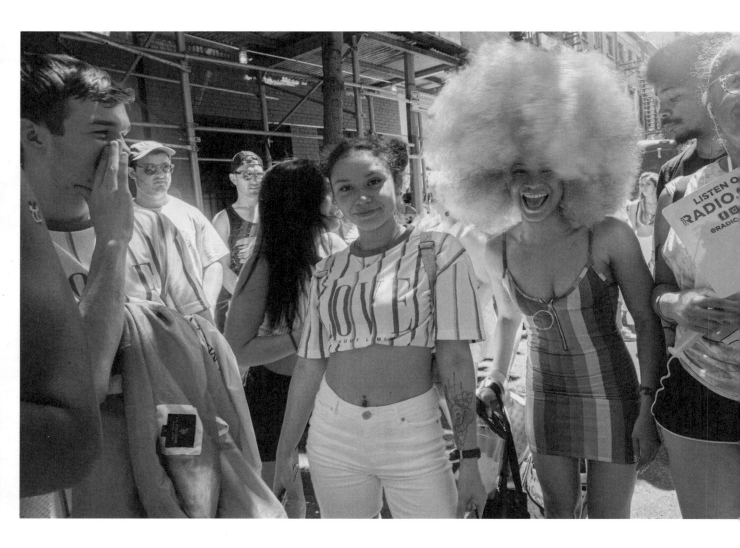

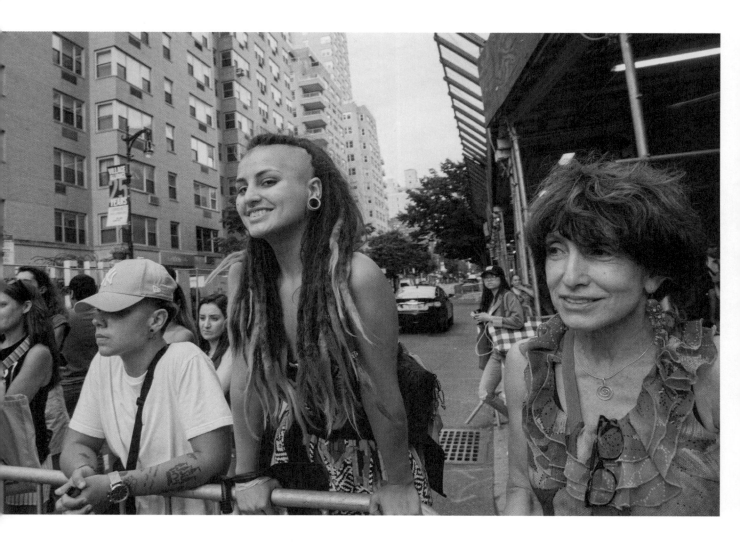

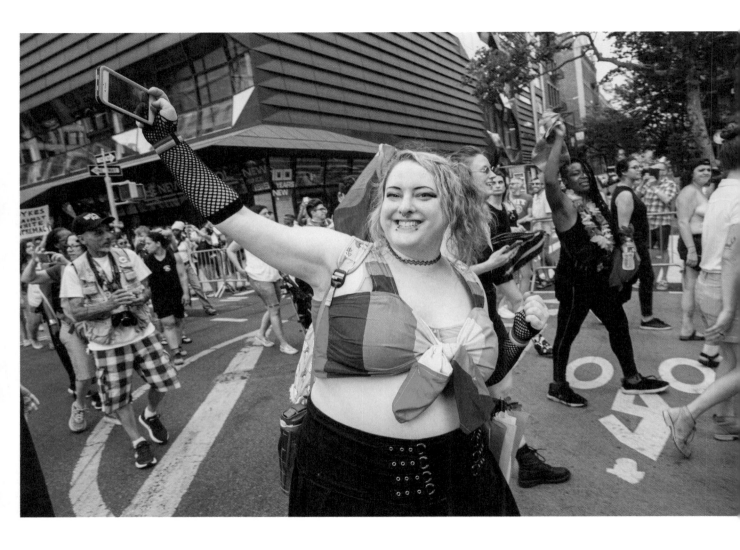

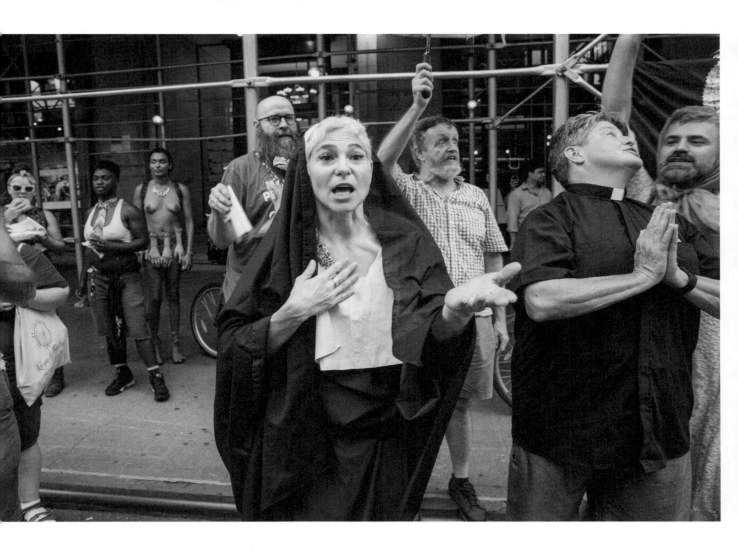

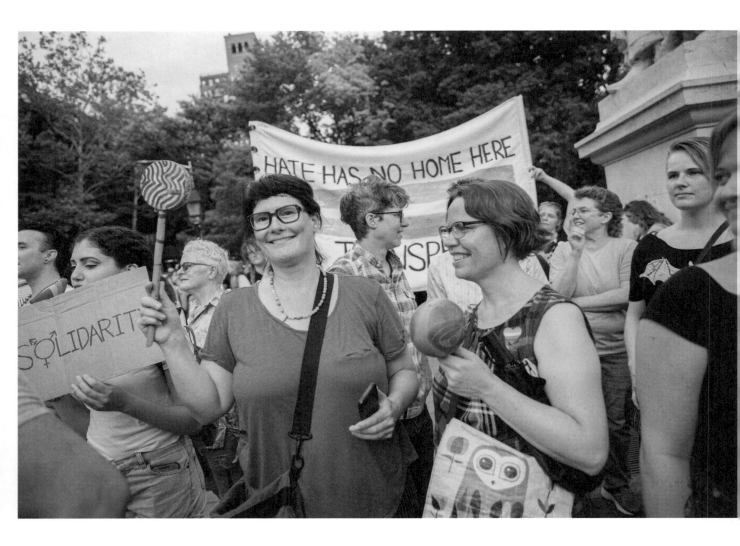

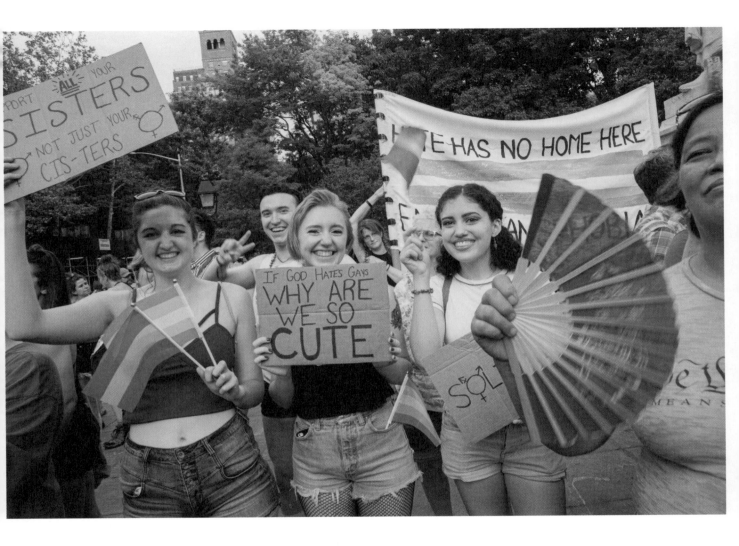

73

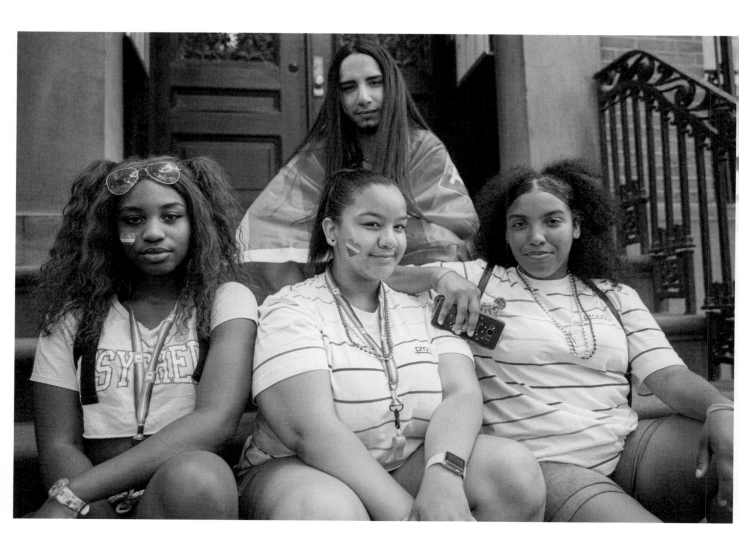

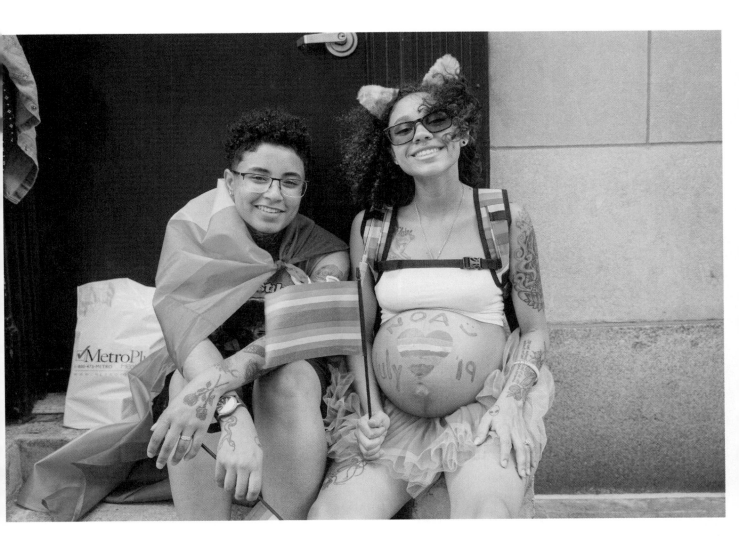

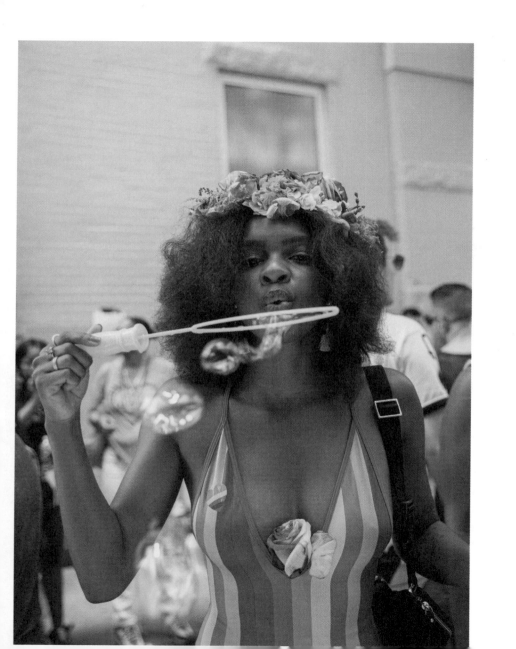

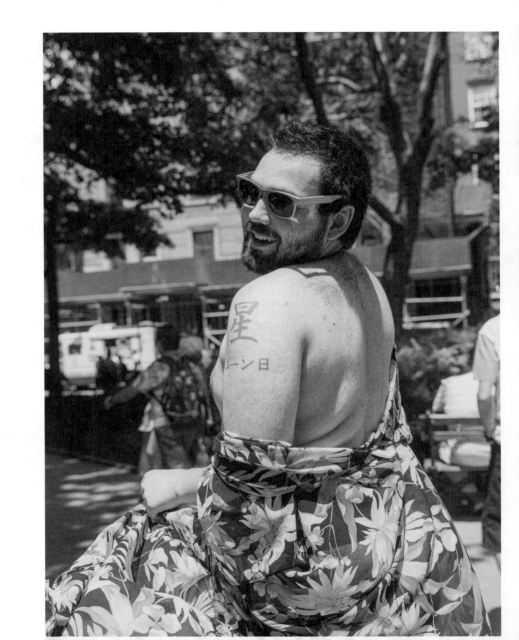

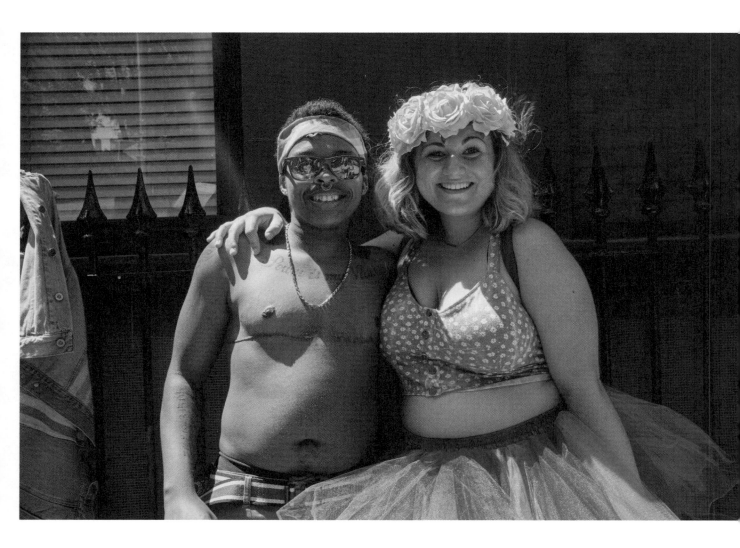

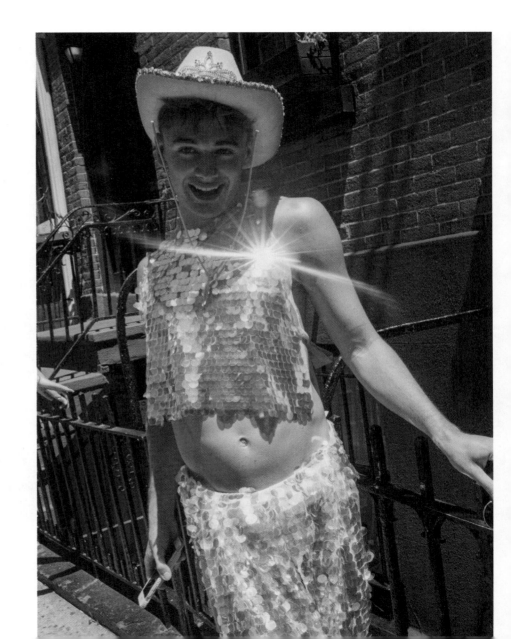

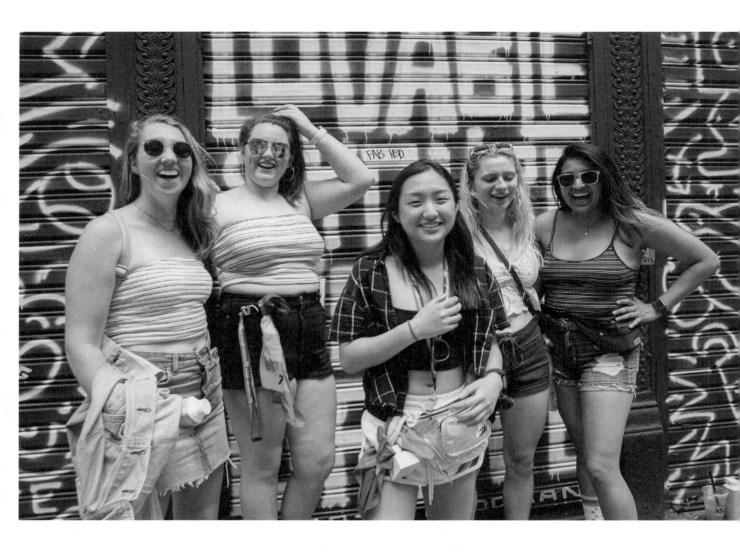

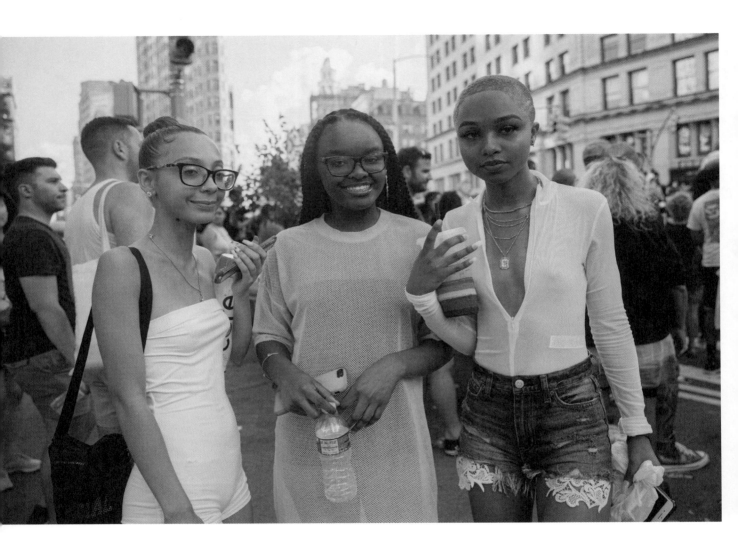

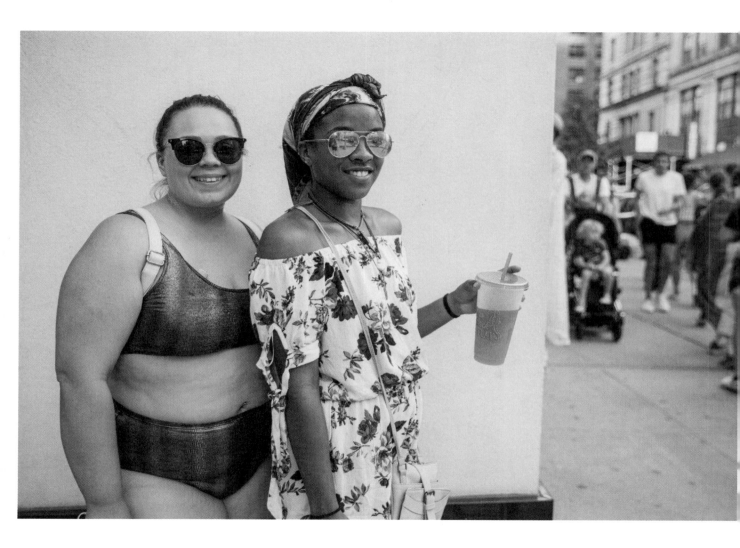

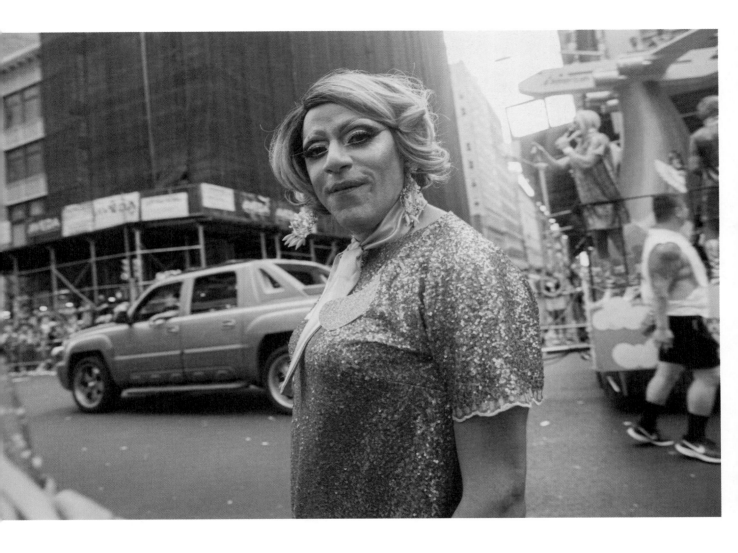

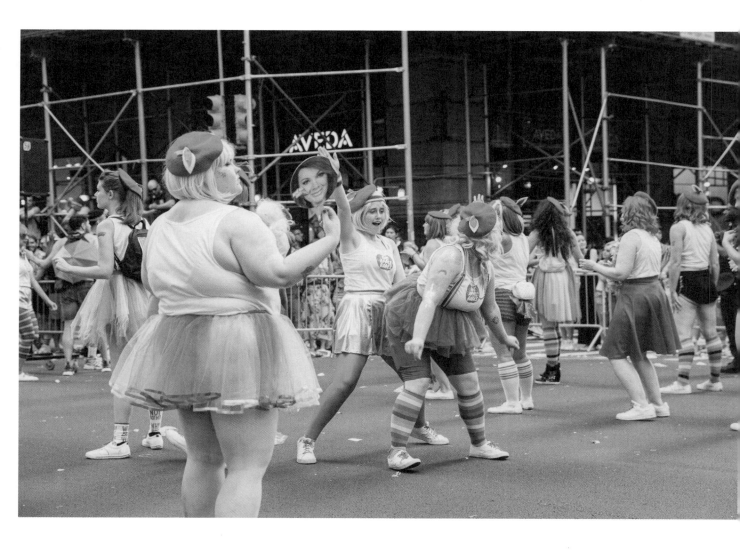

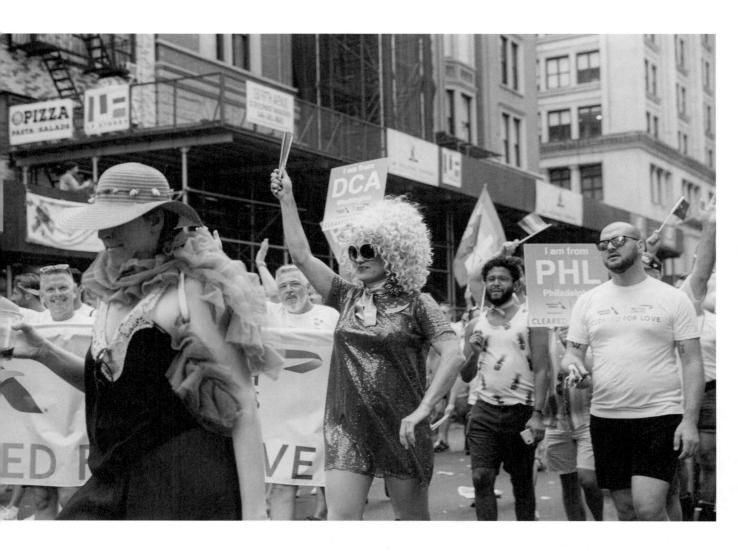

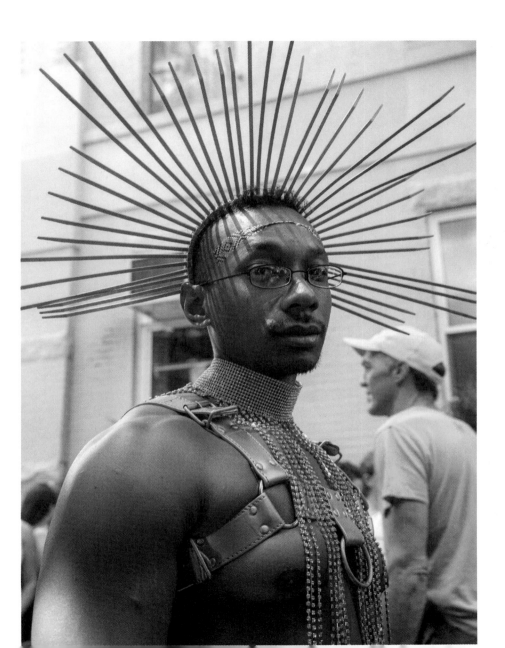

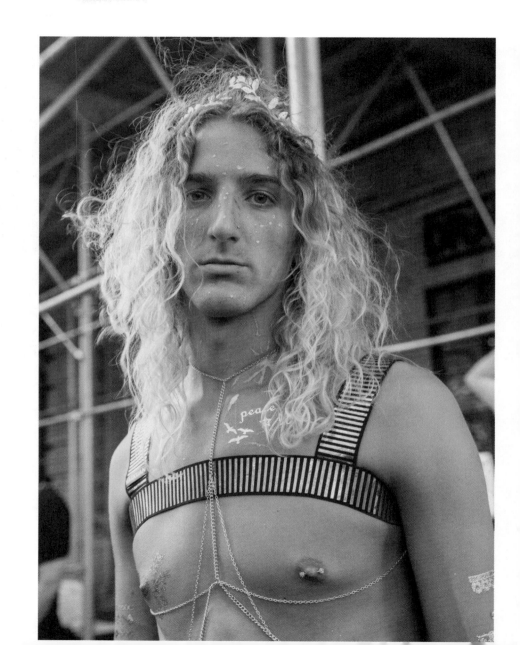

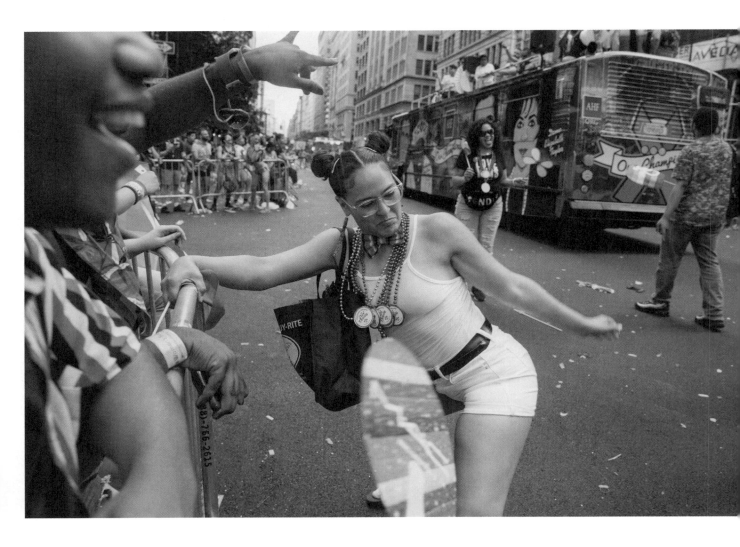

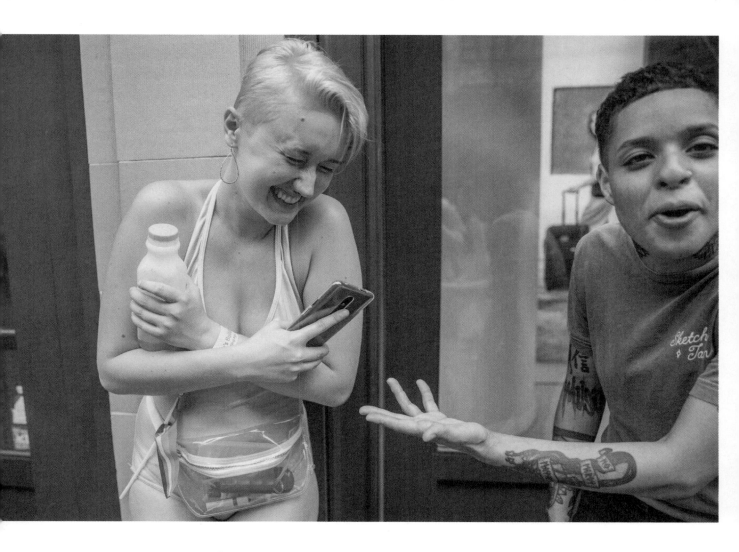

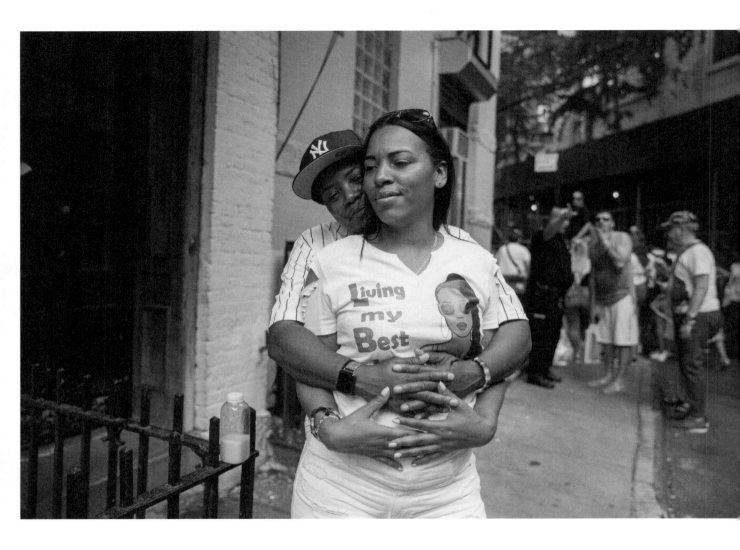

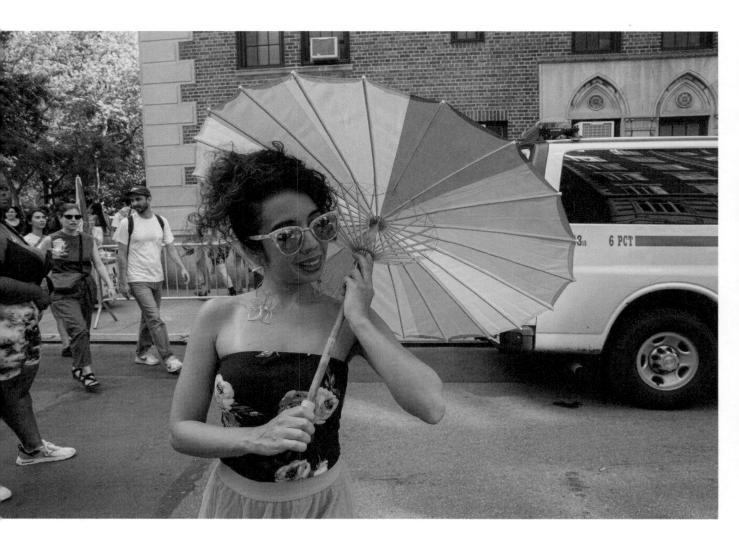

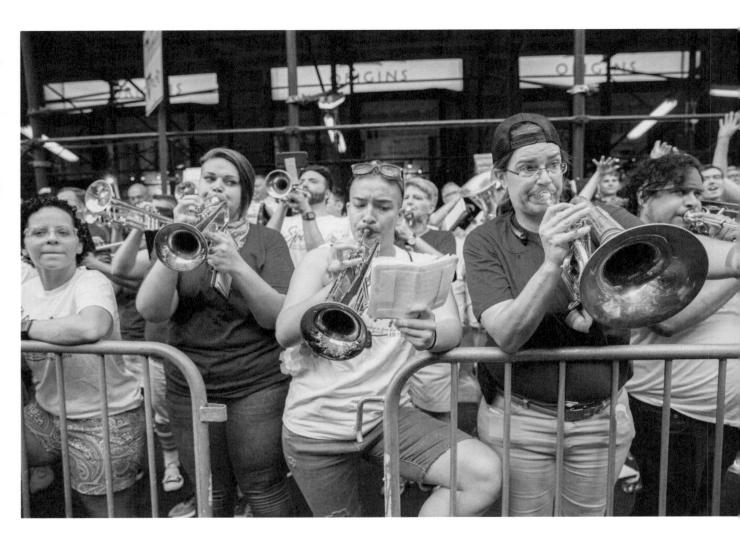

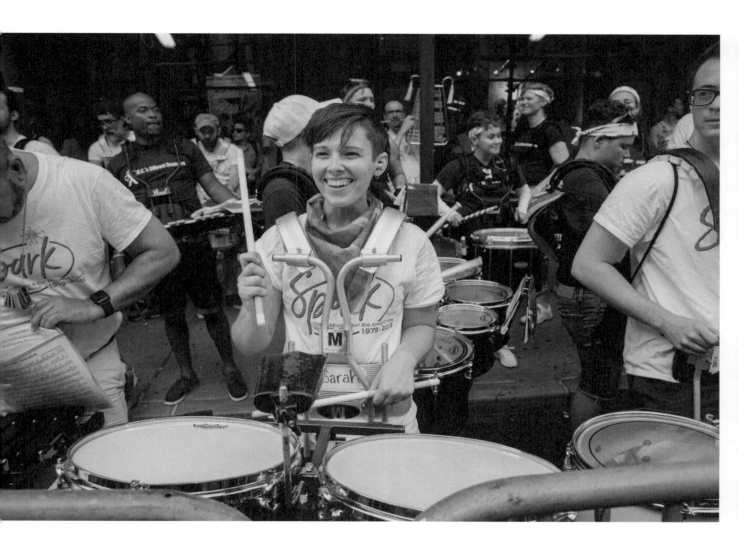

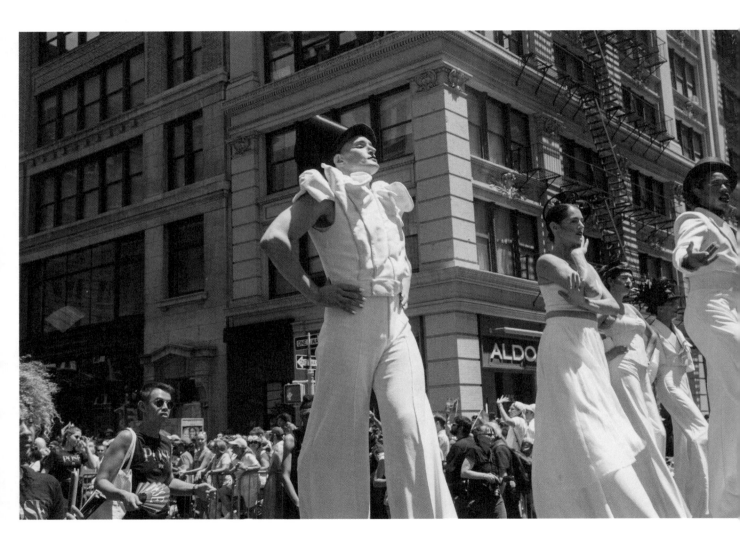

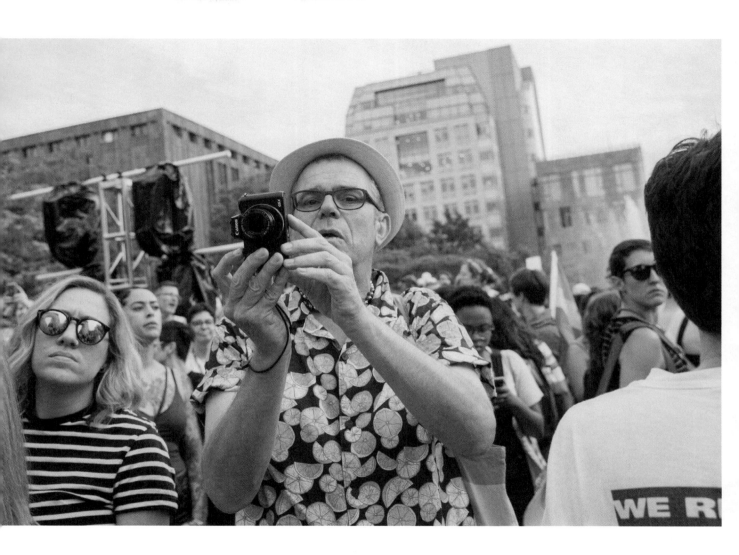

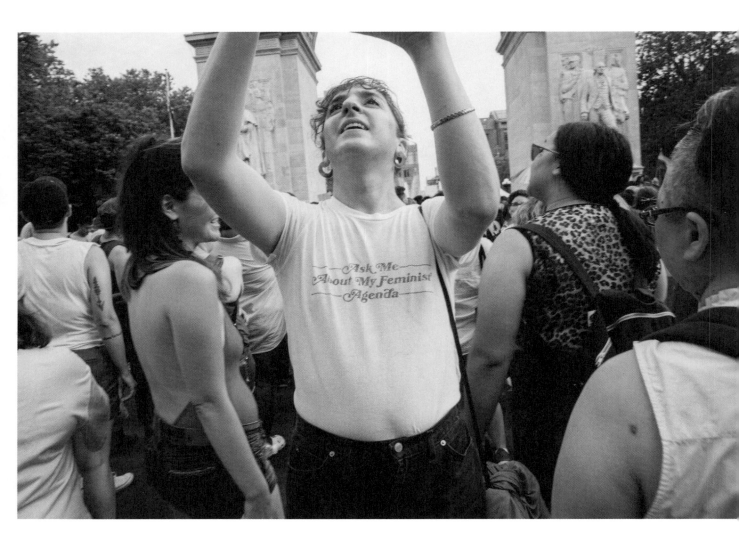

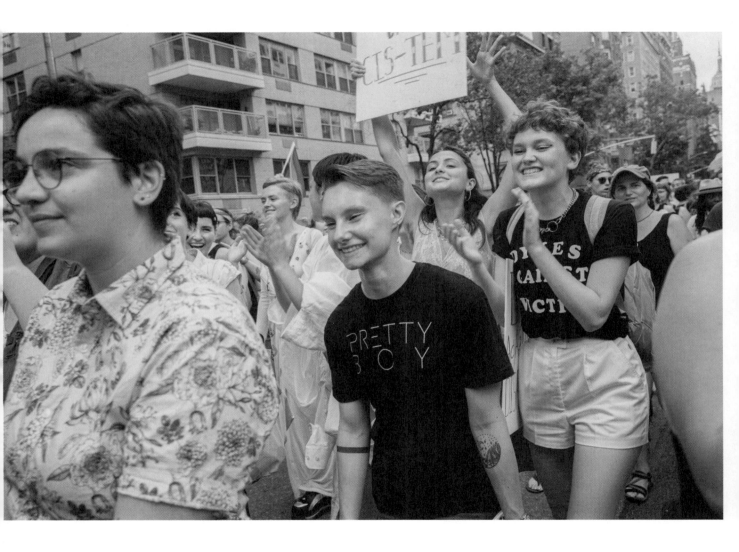

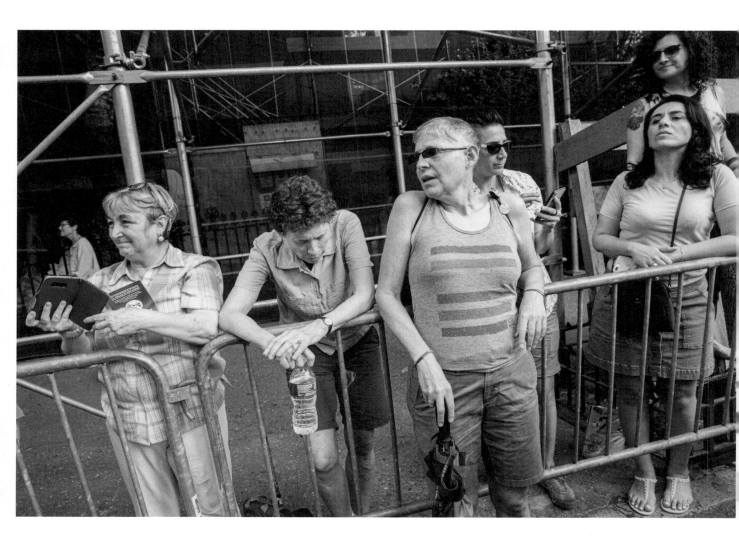

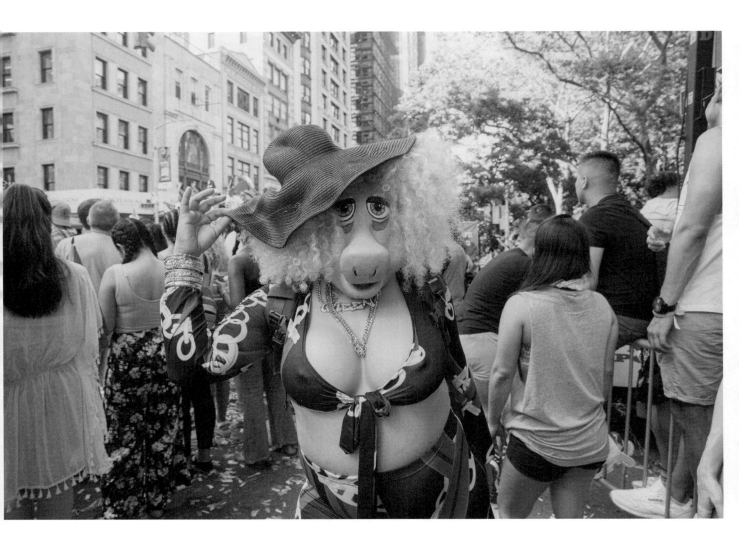

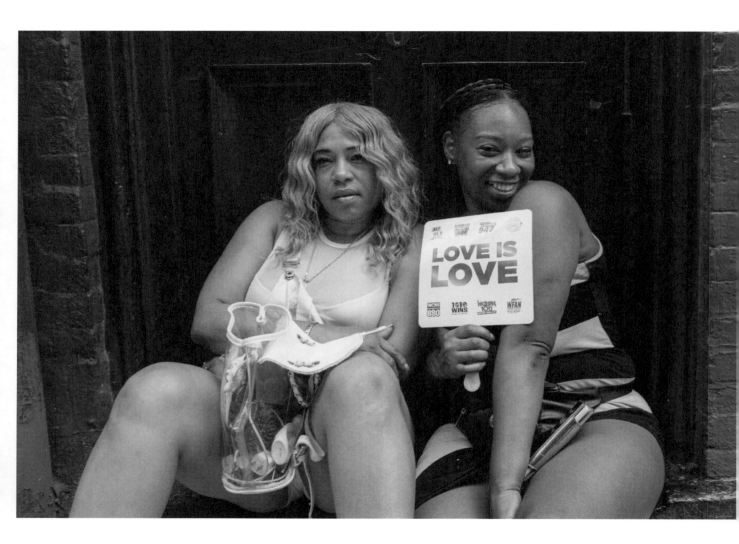

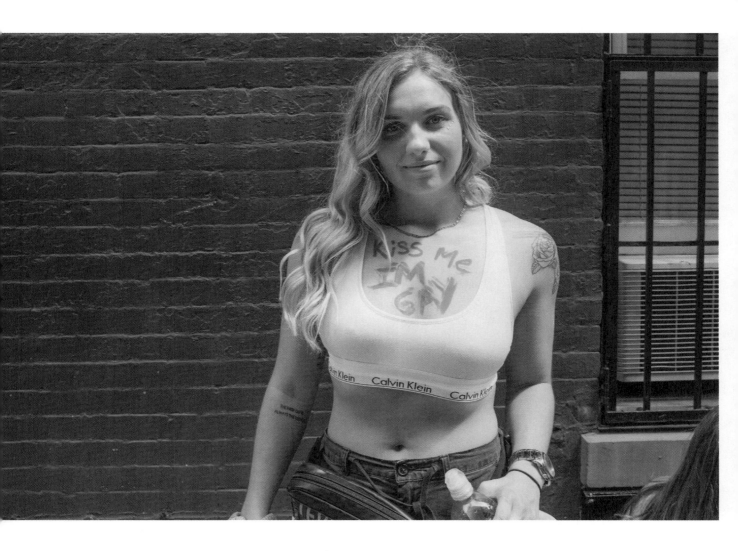

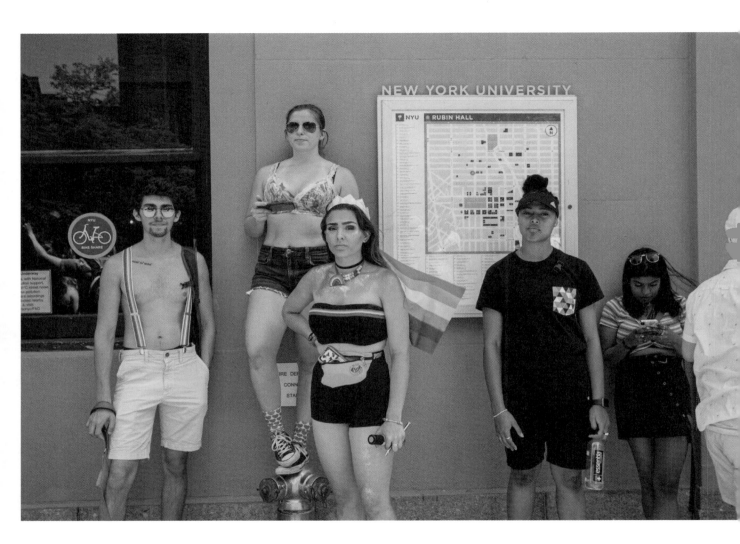

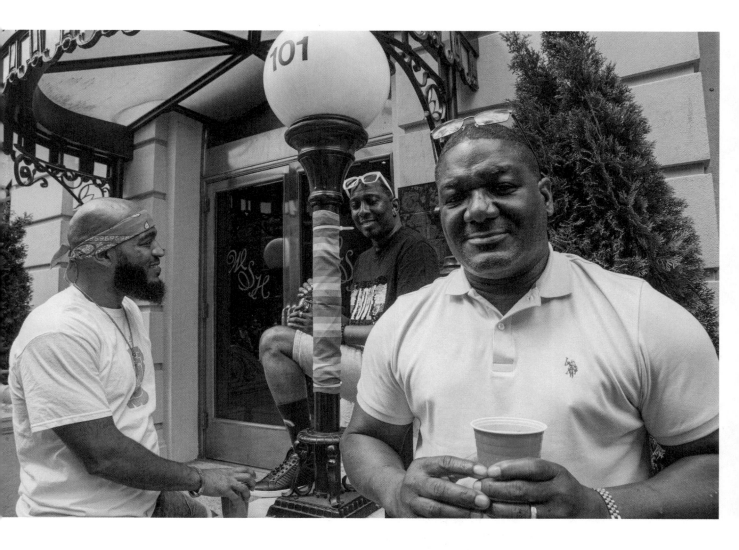

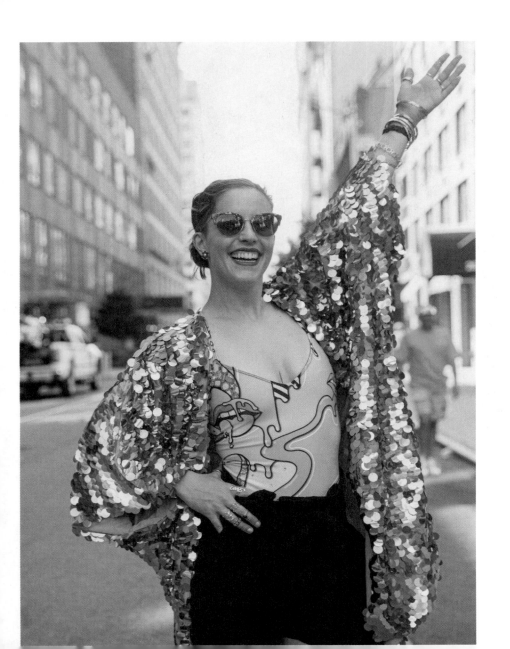

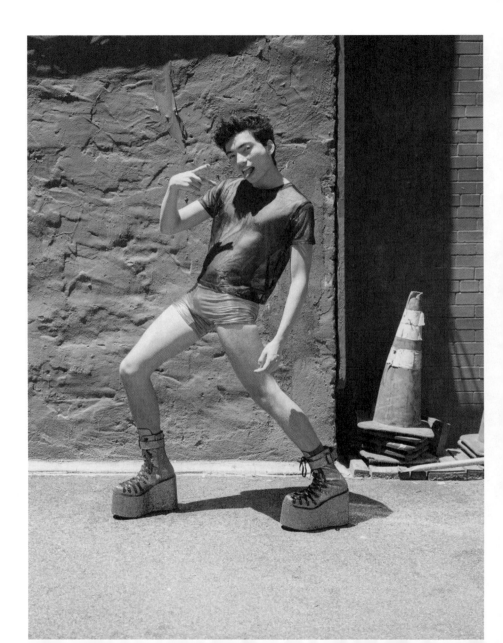

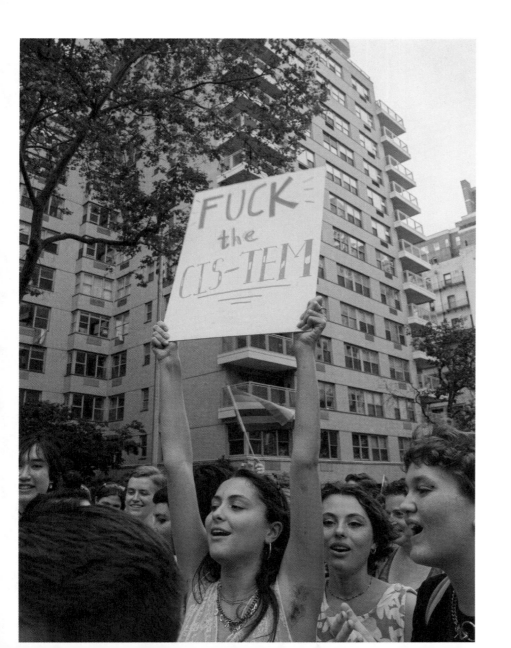

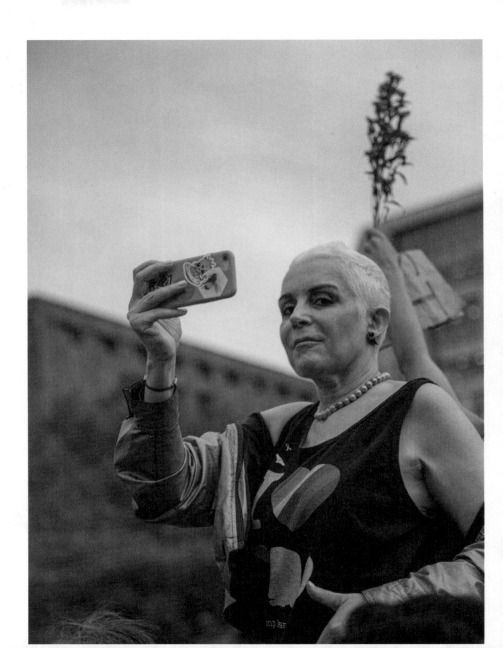

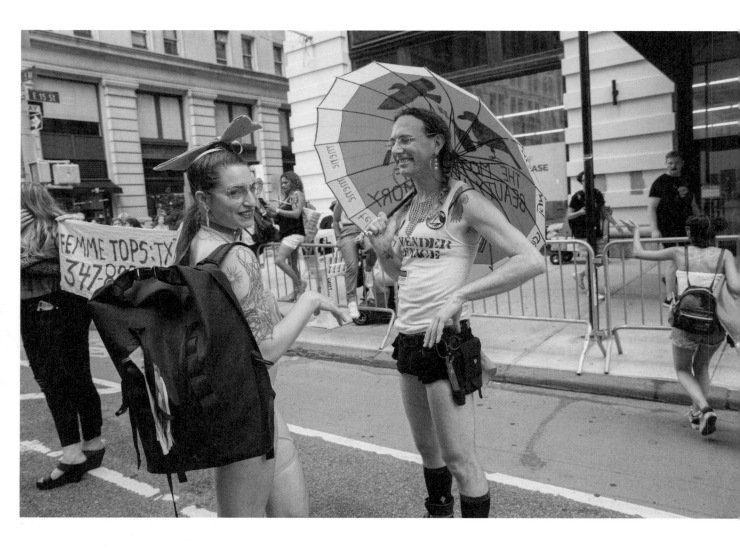

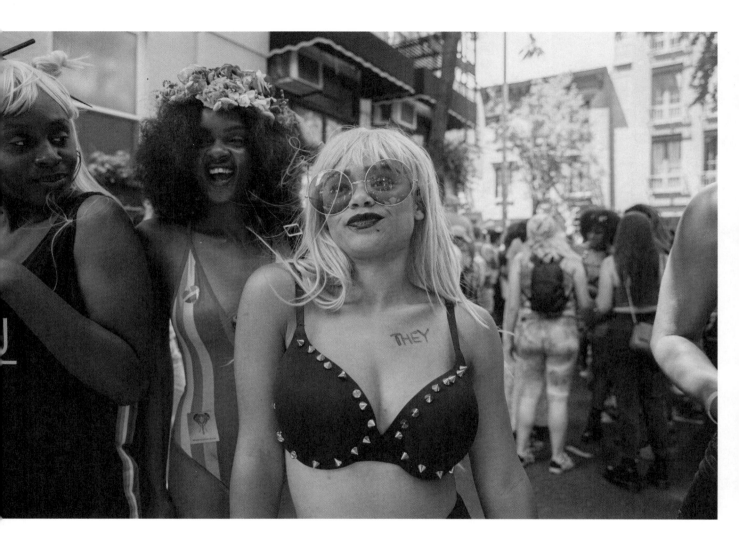

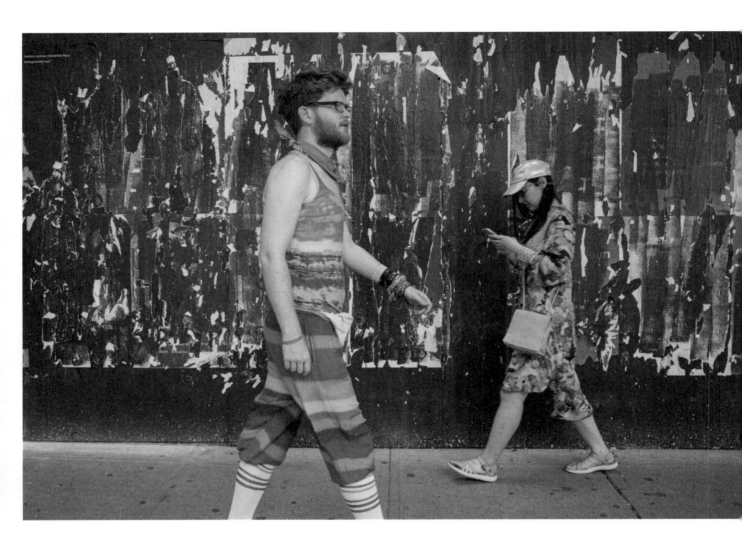

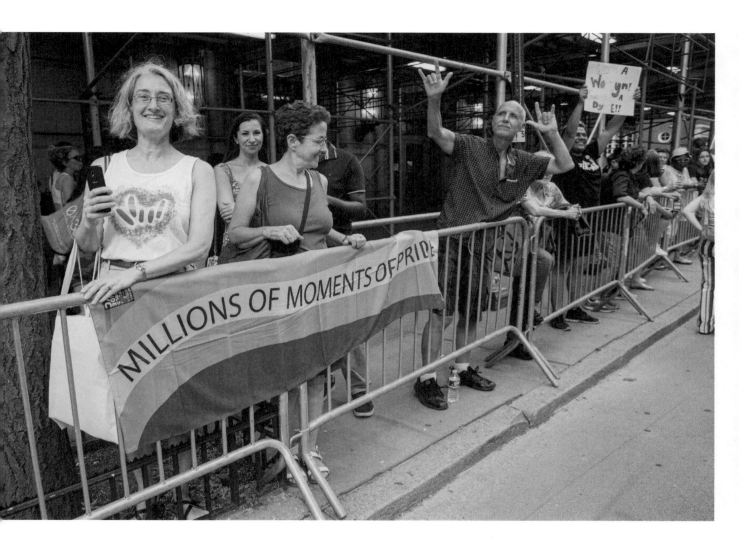

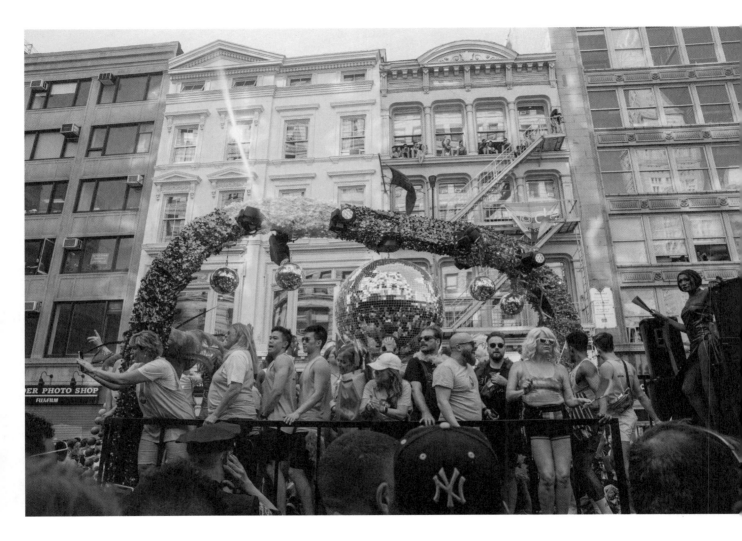

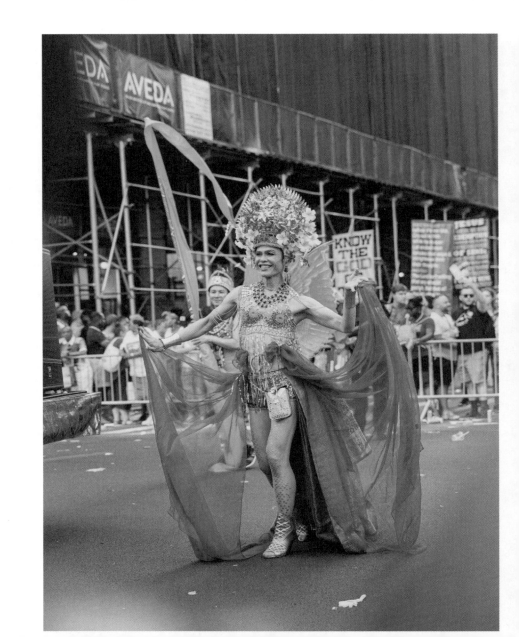

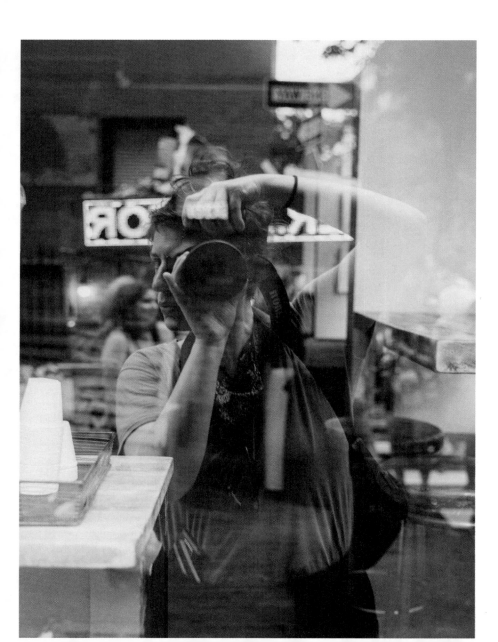

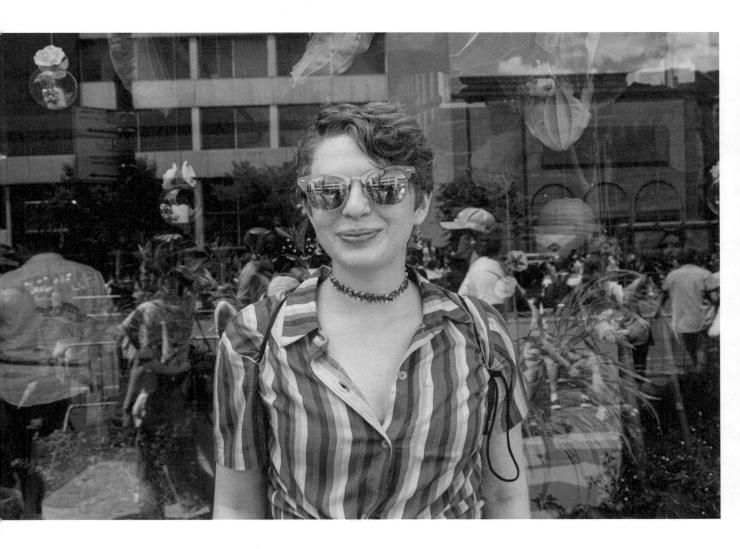

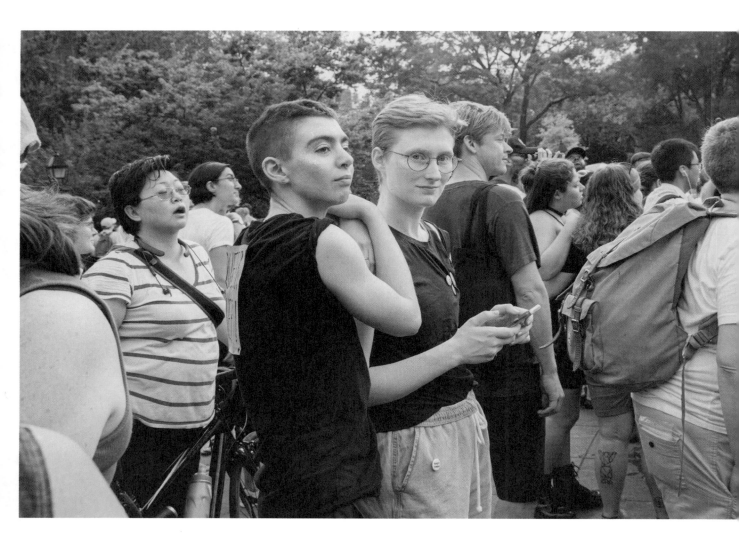

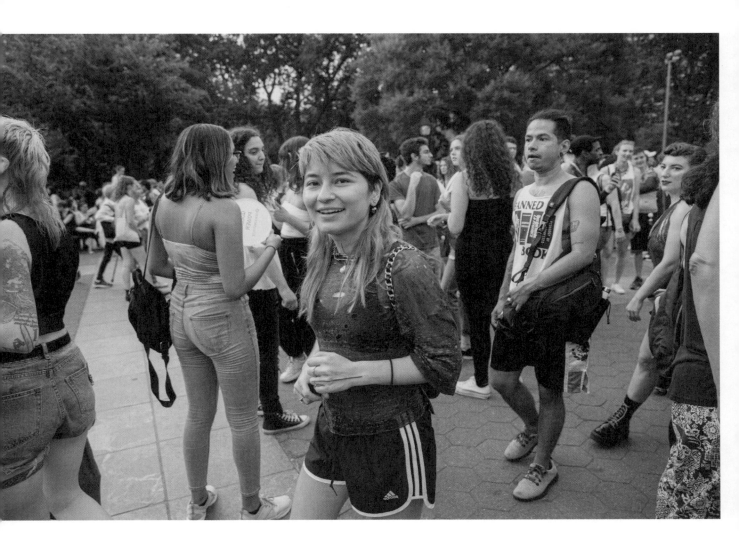

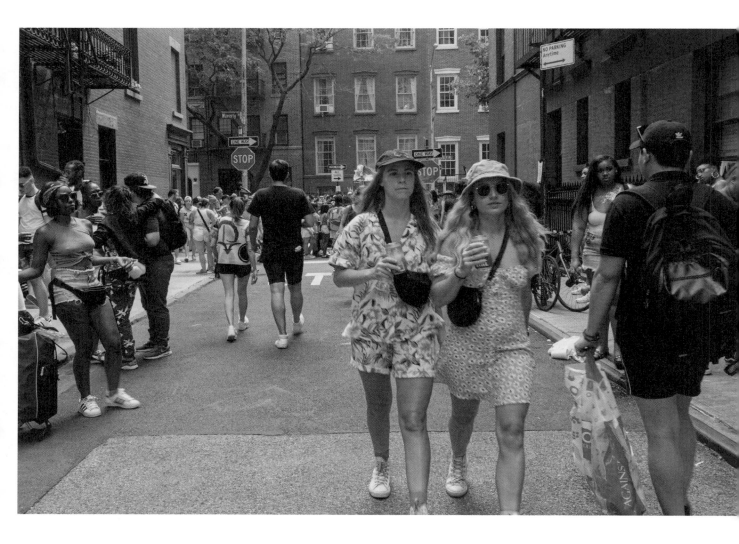

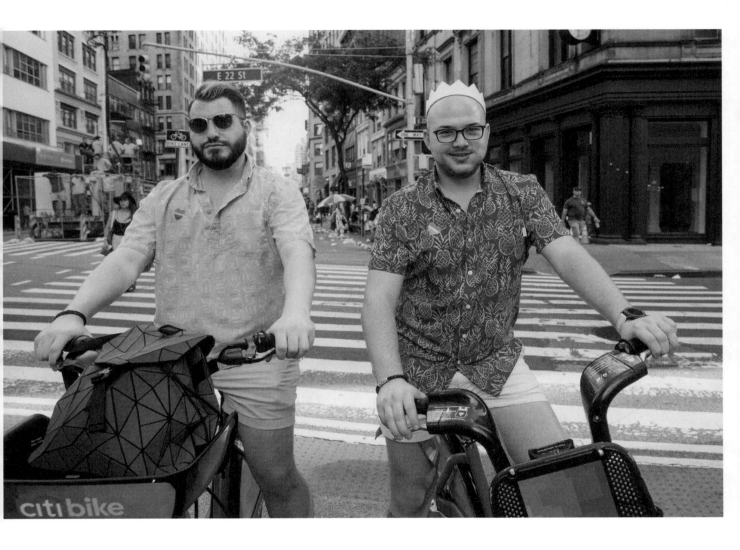

119

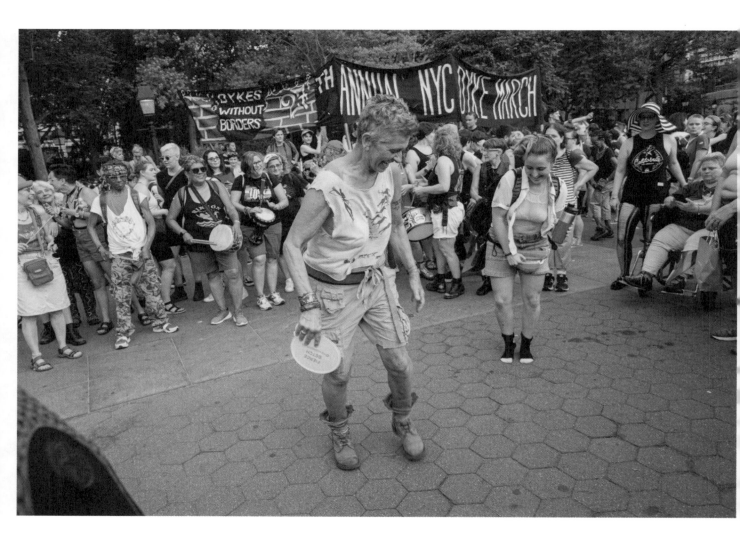

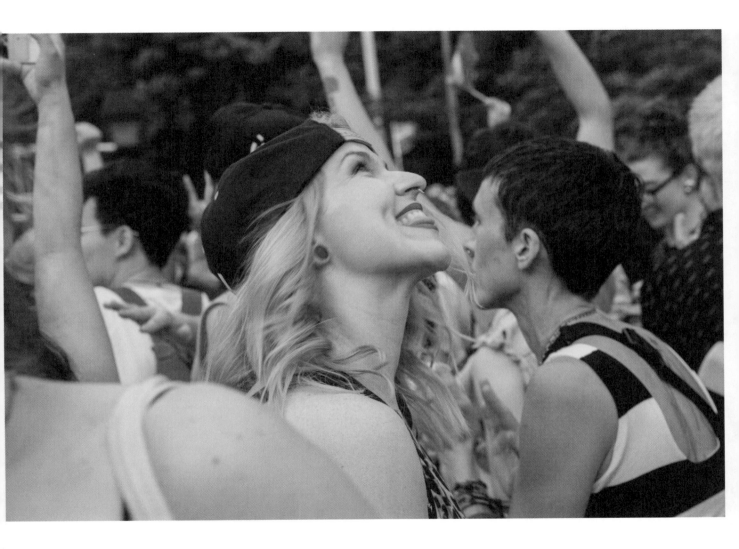

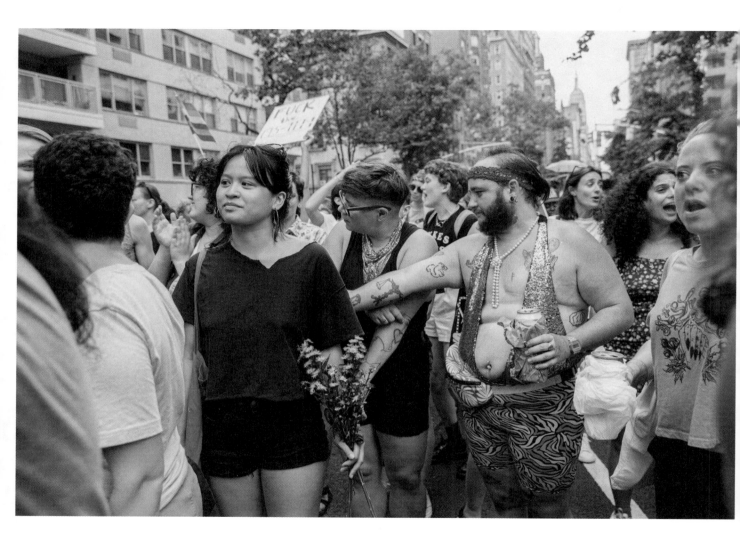

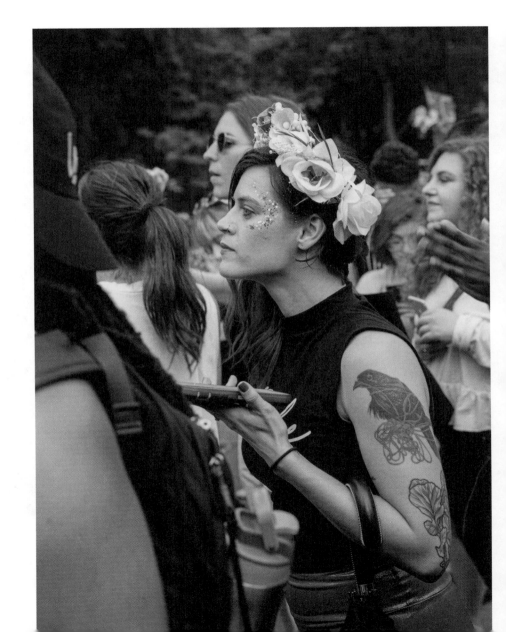

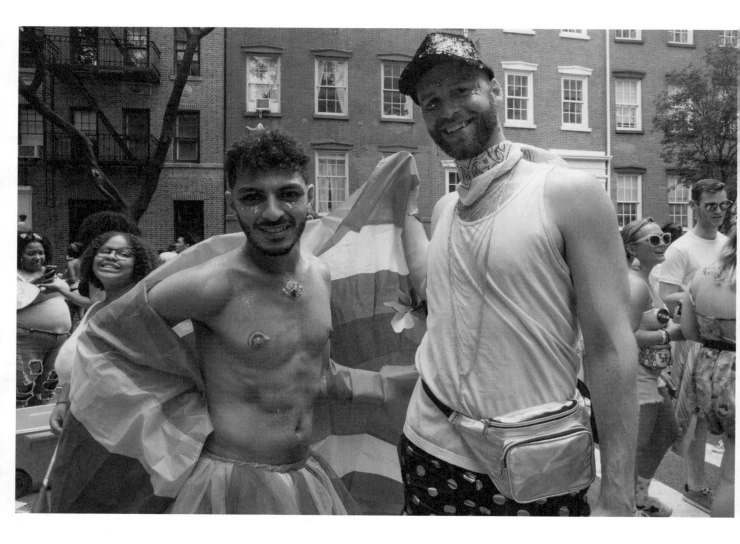

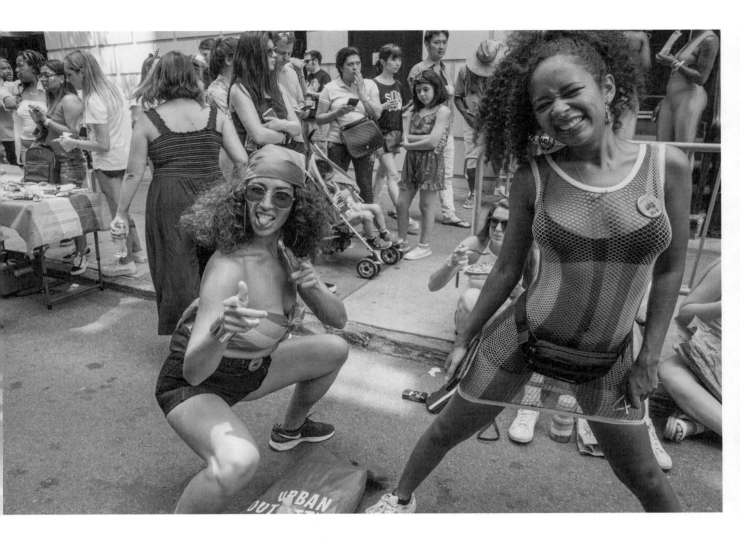

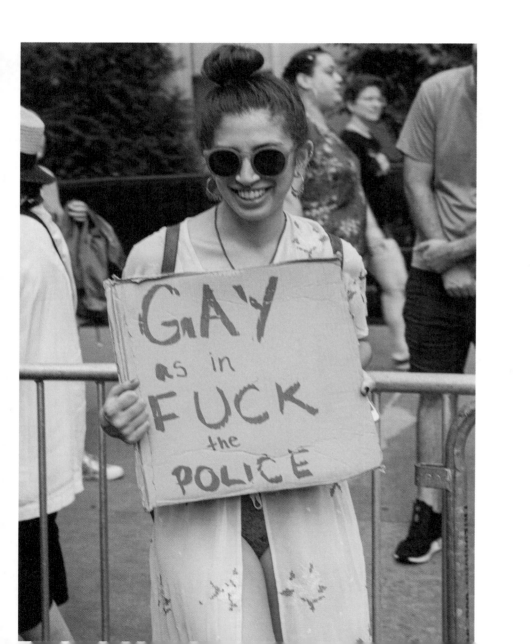

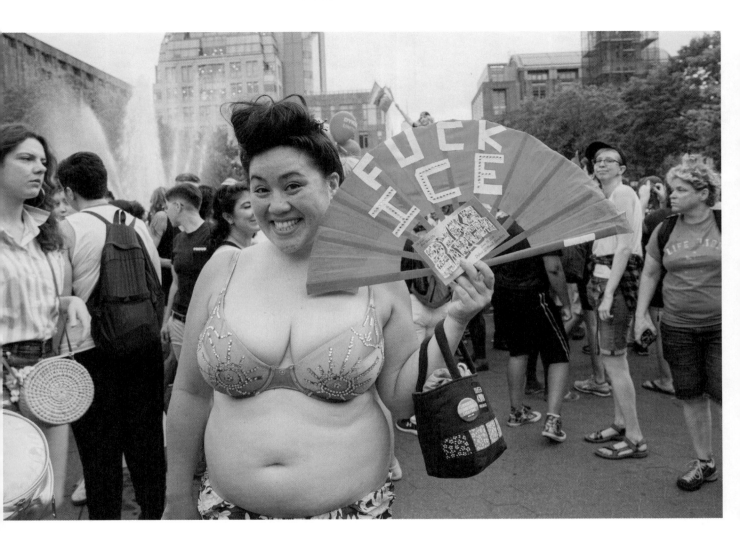

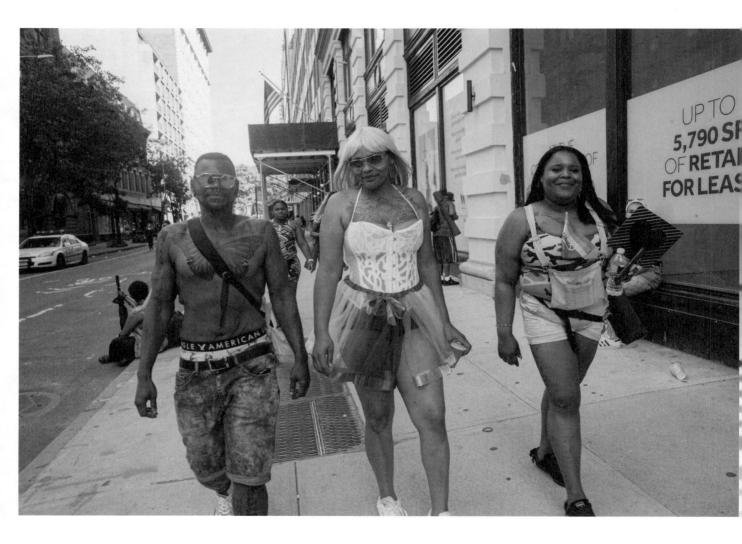

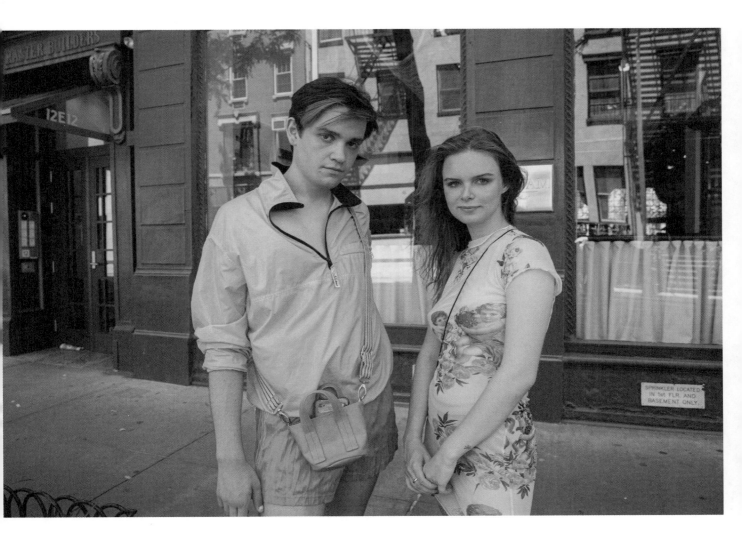

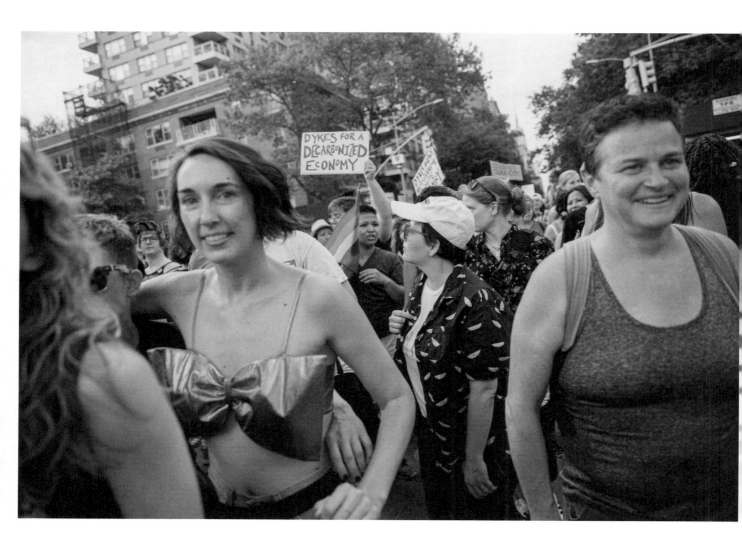

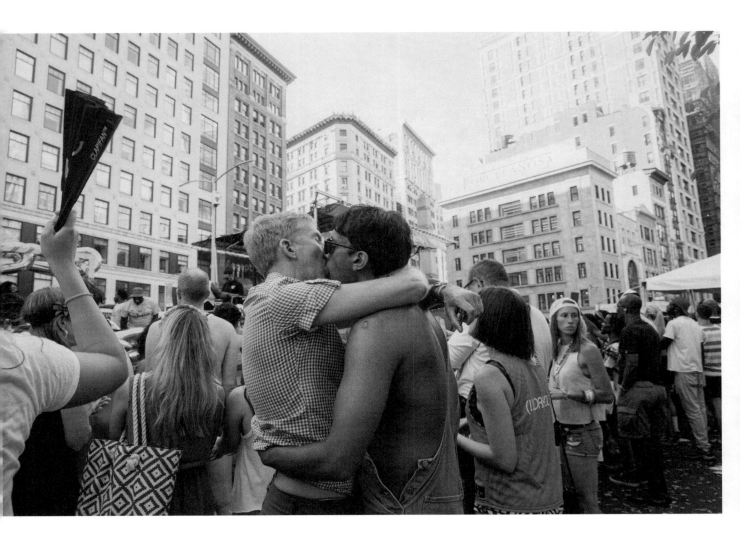

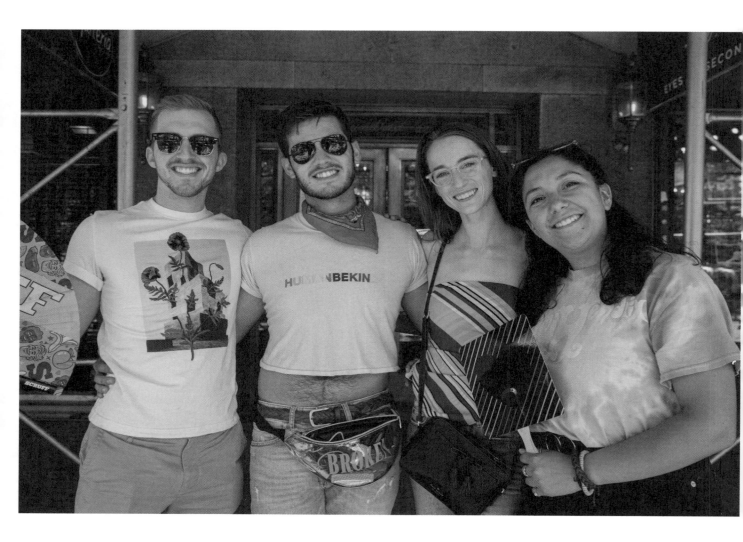

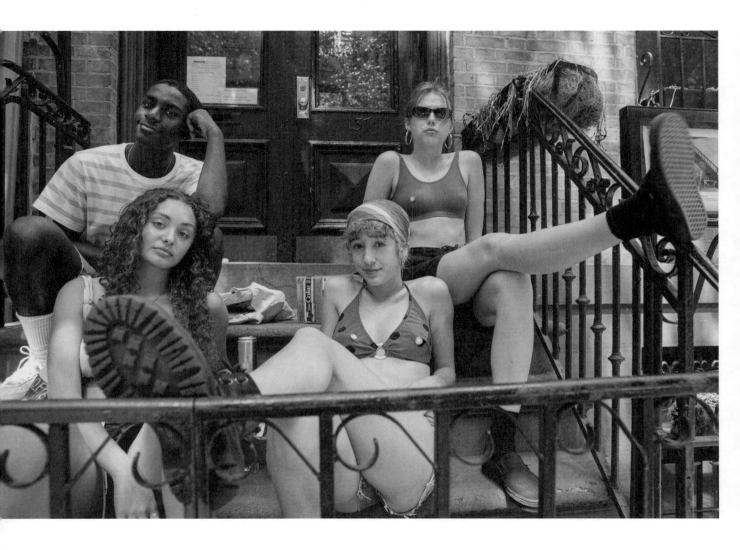

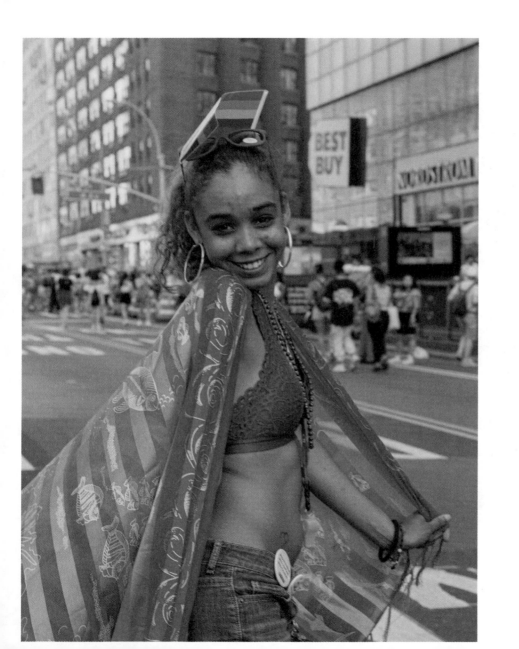

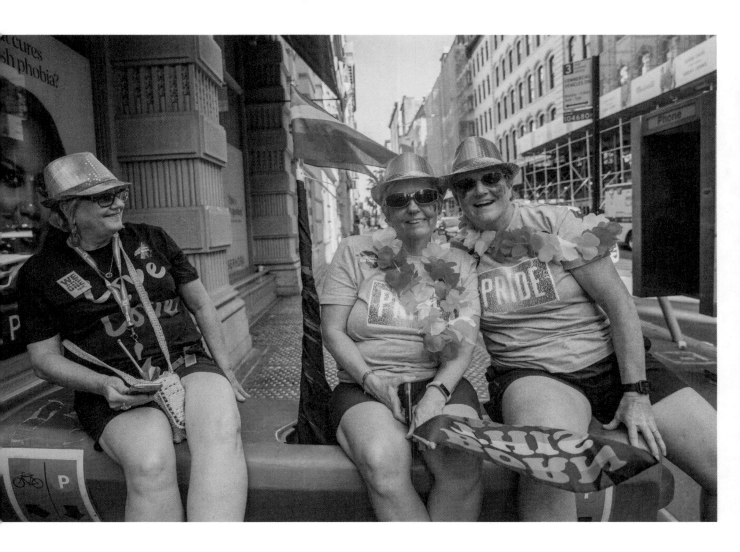

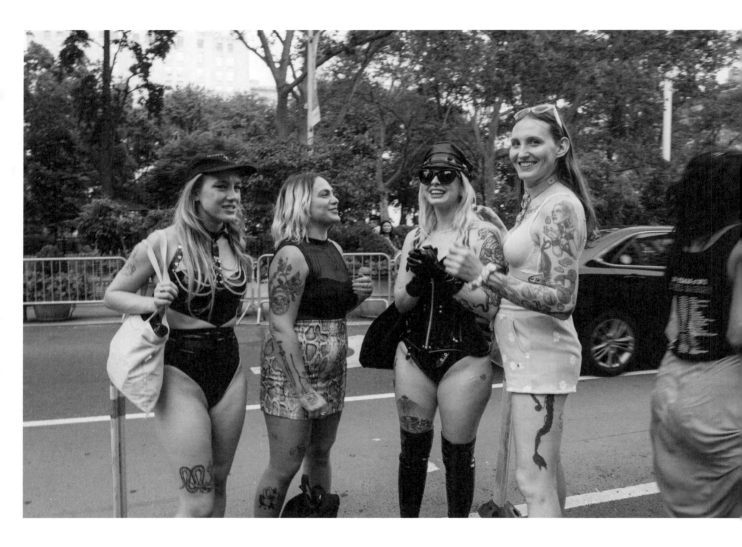

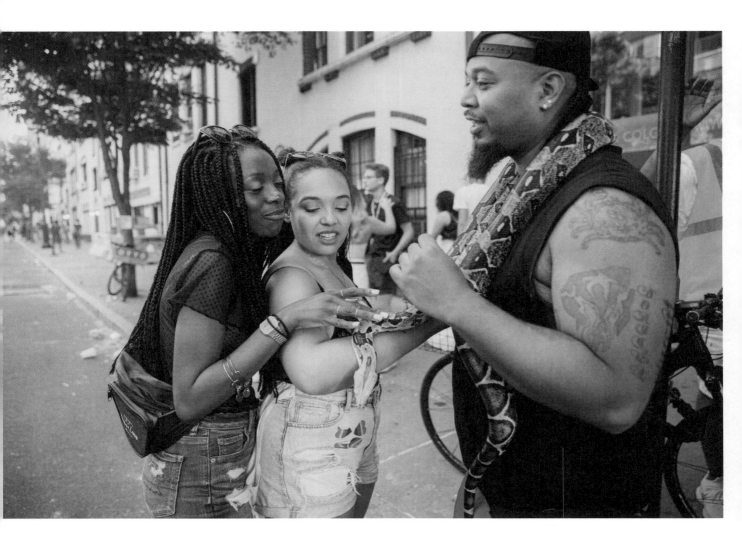

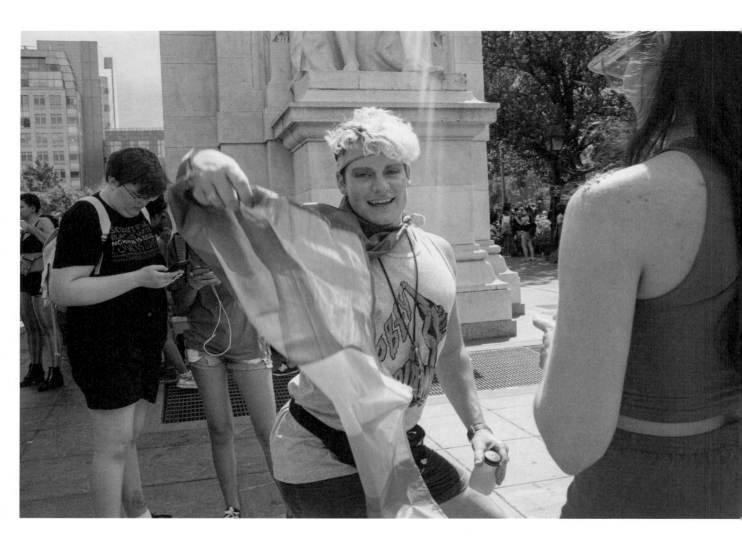

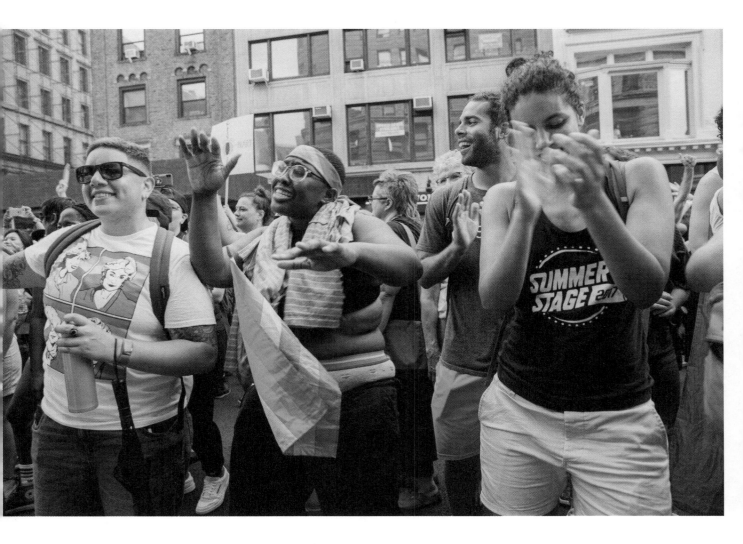

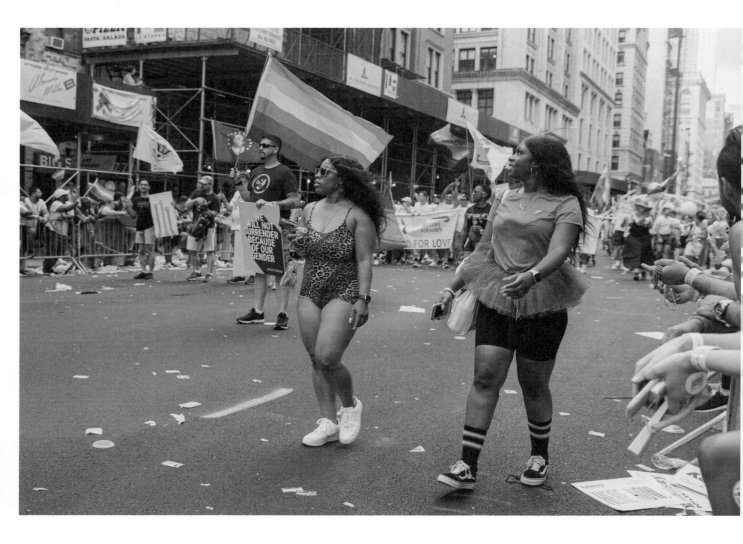

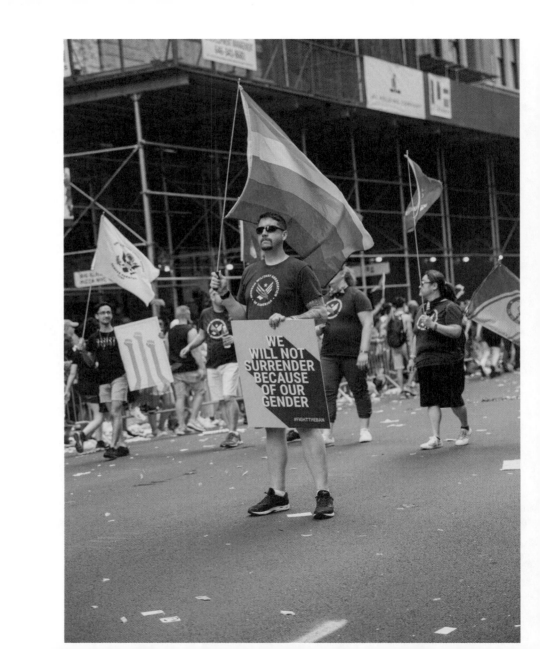

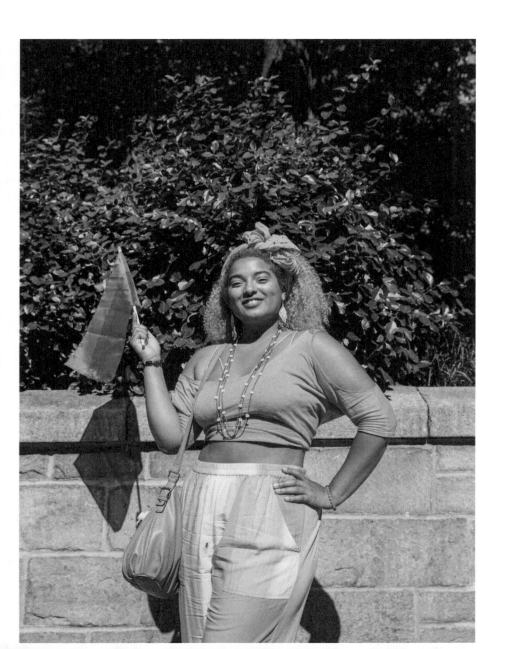

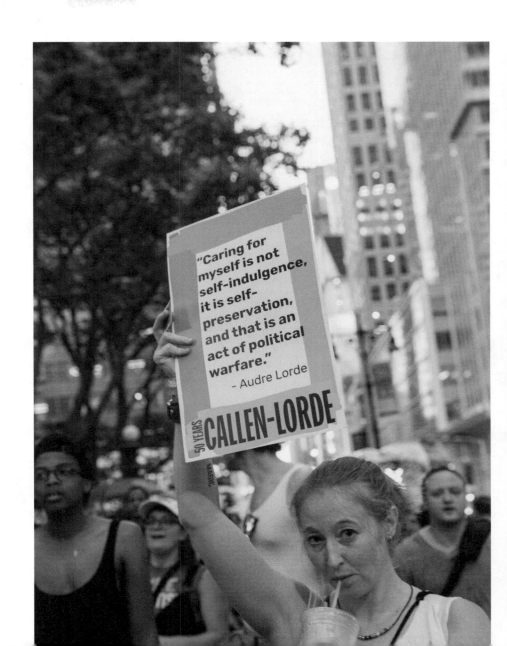

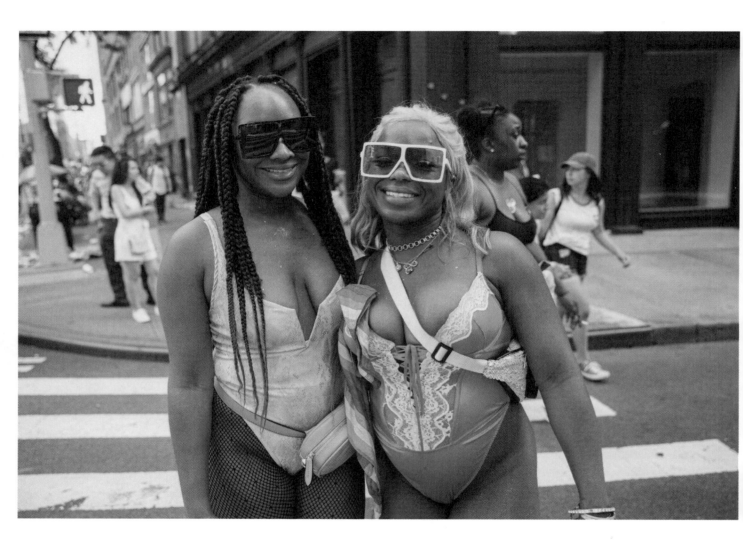

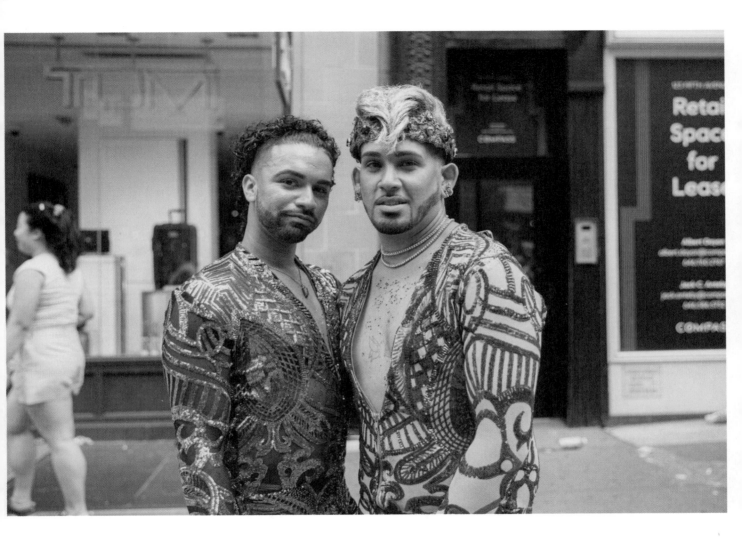

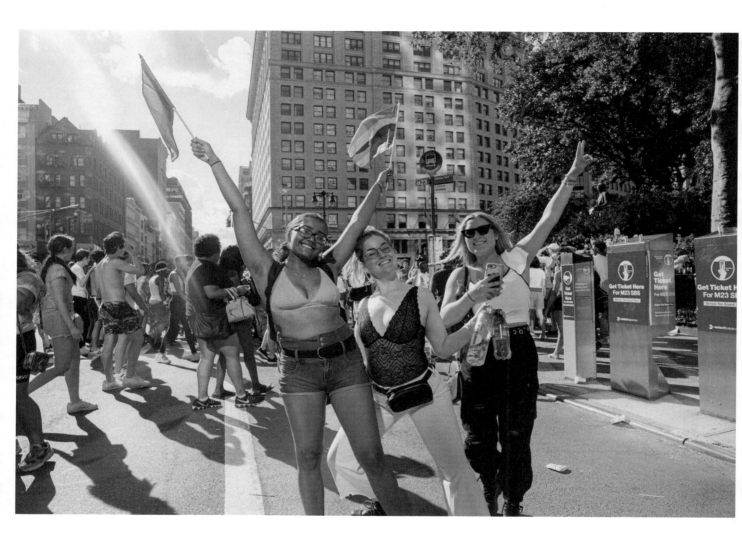

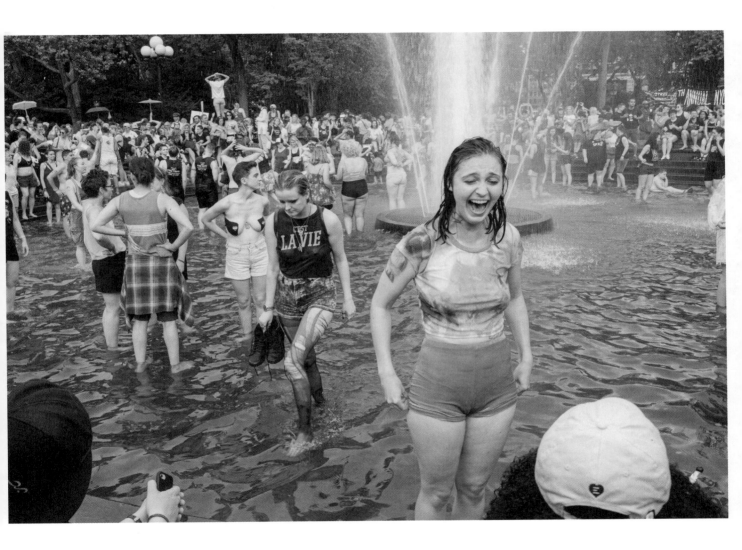

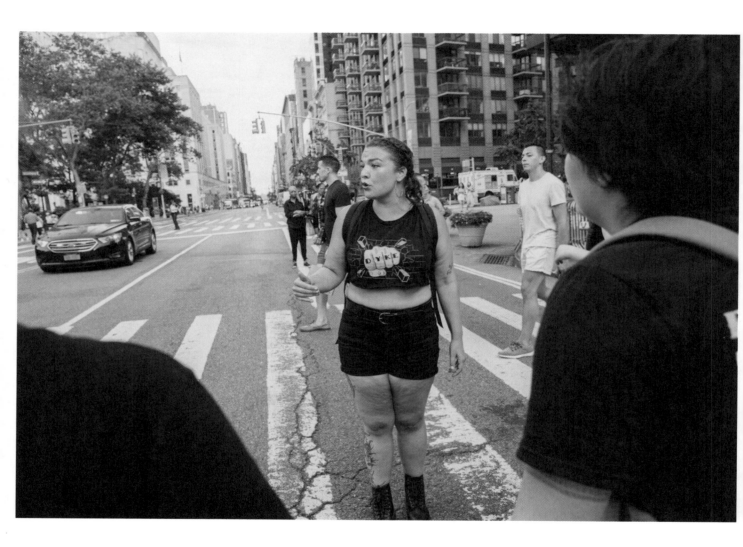

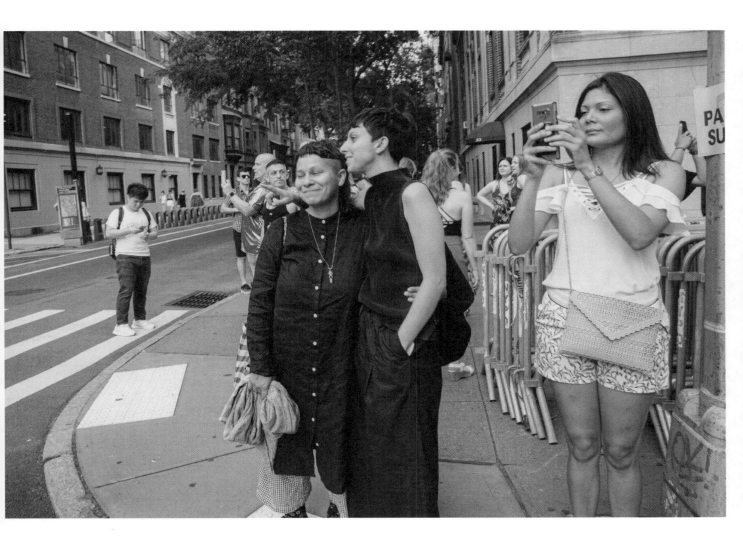

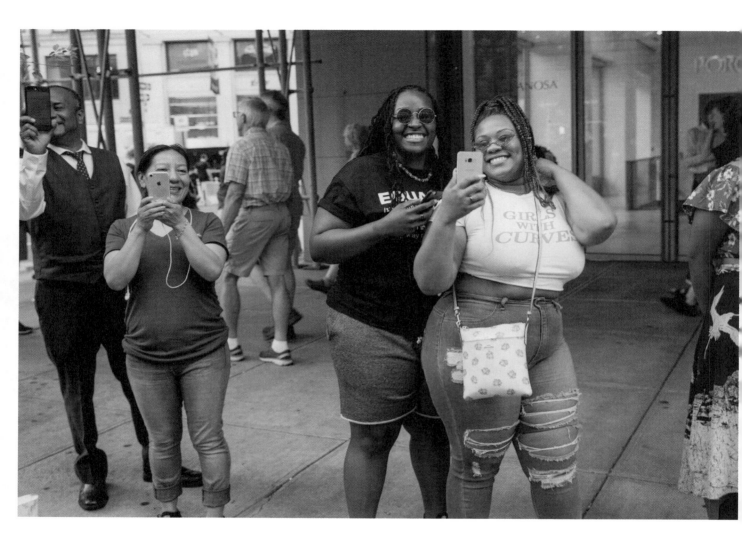

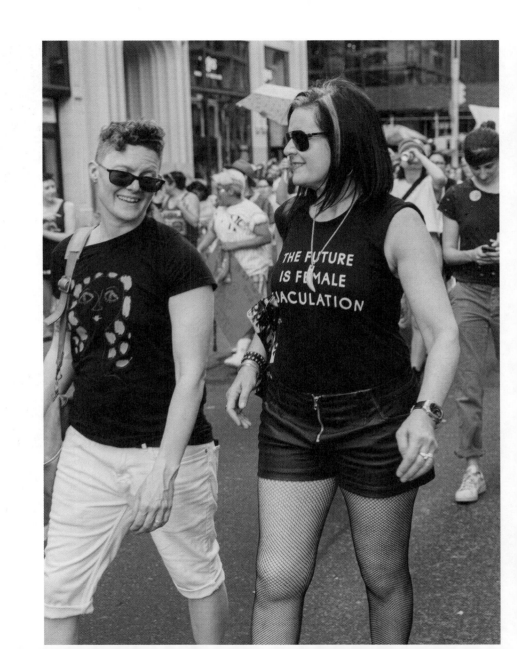

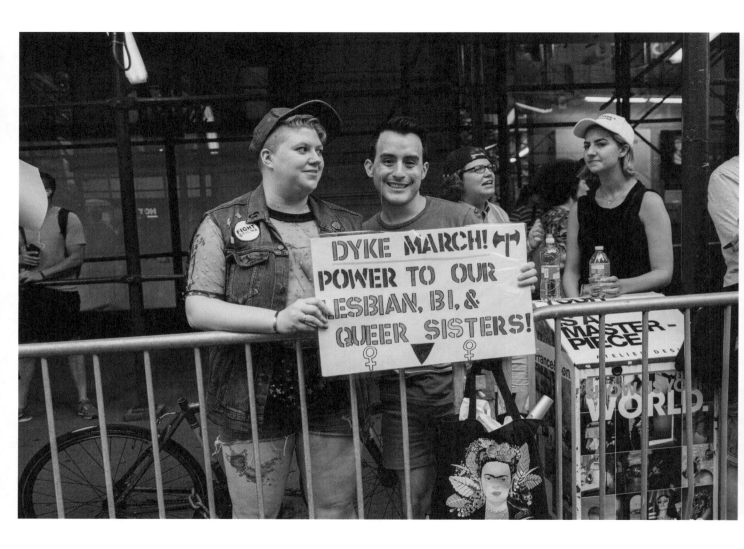

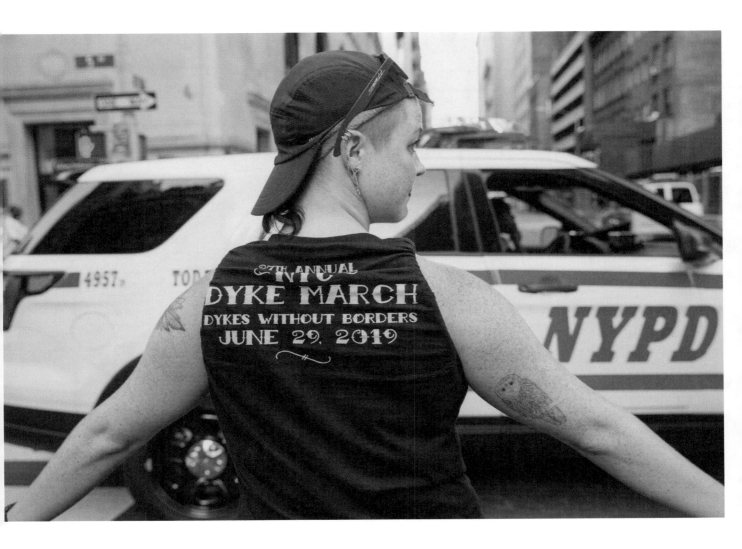

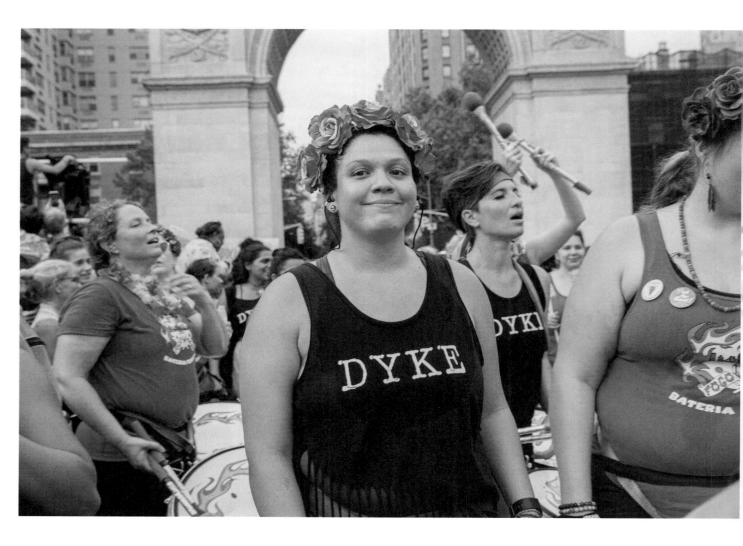

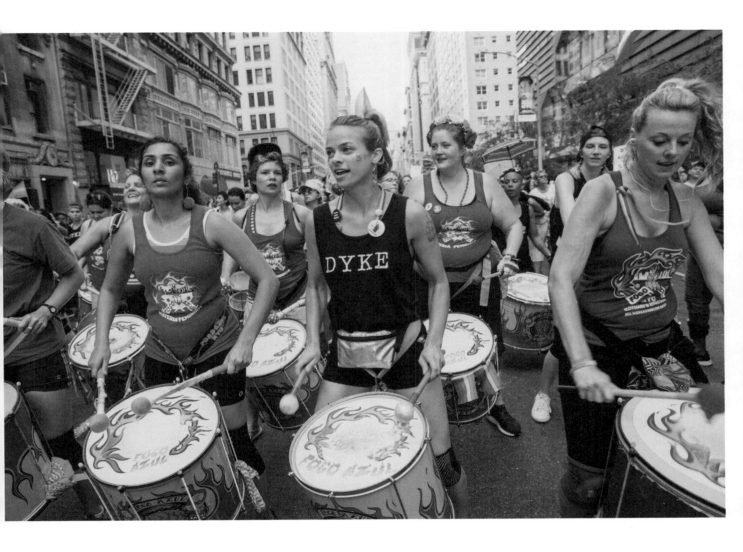

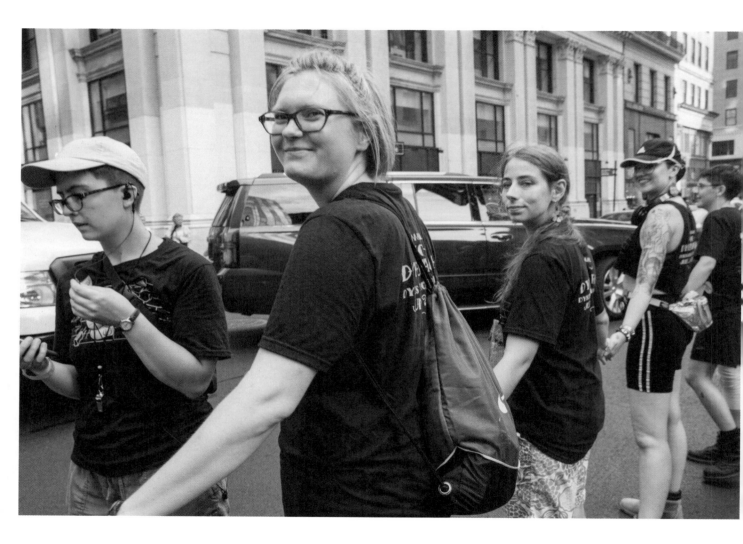

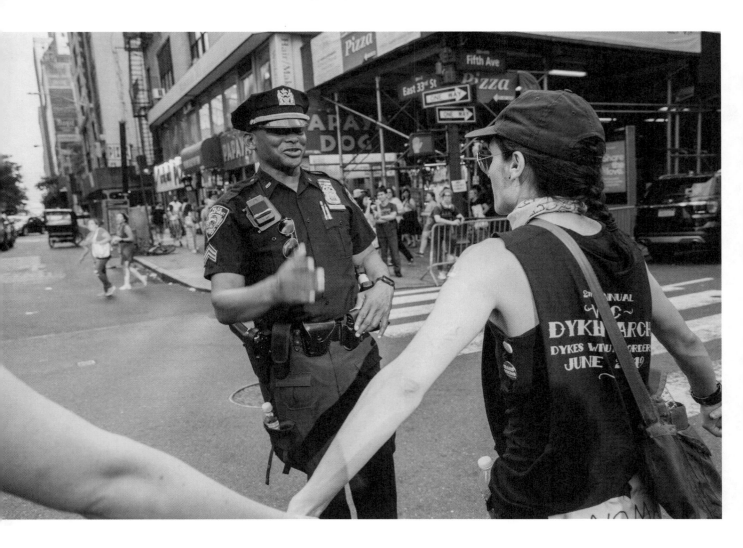

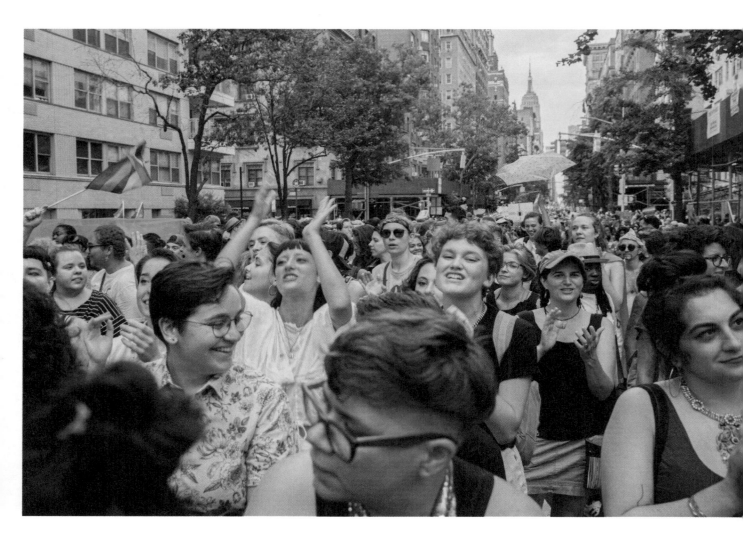

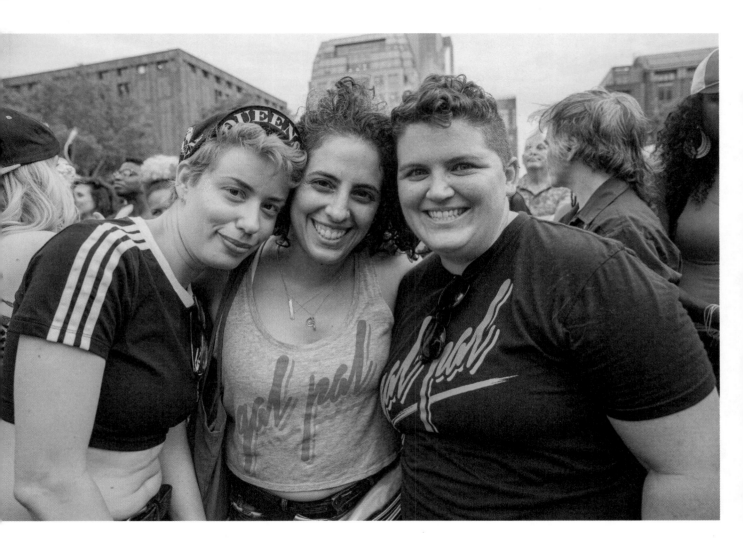

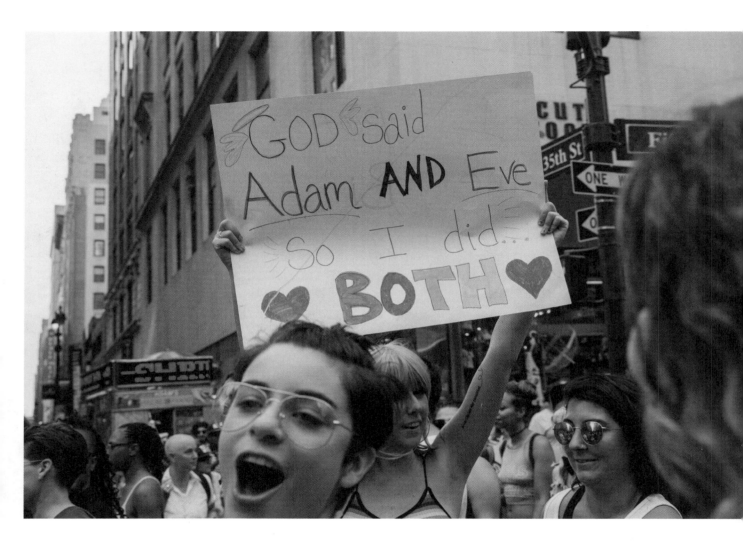